ANTHONY CARO

ANTHONY CARO

TERRY FENTON

with 172 illustrations, 98 in colour

THAMES AND HUDSON

First published in Great Britain in 1986
by Thames and Hudson Ltd, London

Printed in Spain by La Polígrafa, S. A., Barcelona (Spain)
Dep. Leg. B.: 22.868 - 1986

CONTENTS

Transformation

The art of sculpture is unique. Unlike pictorial art and literature, it occupies real space in the world, and unlike the performing arts it occupies that space permanently. Because it occupies space, it must compete with other objects: with natural ones like rocks and trees as well as with a multitude of man-made ones. Most of the latter — furniture, buildings, tools, and machines — serve some purpose. Sculpture alone occupies space for its own sake. While it can be argued that sculpture often represents bodies, and that this amounts to a kind of purpose, representation need not take up space; it can be accommodated quite adequately by pictorial art, and that art calls for surface alone.

Because it occupies space, sculpture is at once the most and the least artificial of art forms. On the one hand, it is an utterly purposeless fabrication, while on the other it is uniquely *real*. While the reality of sculpture is founded upon simple objecthood, it extends beyond it. Objects become sculpture through a kind of heightened presence that separates them from the world of things and events. Sculpture without this presence is not worthy of the name.

Traditionally, the artifice of sculpture has inclined to representation, specifically to representation of the body. In doing this, it quite literally "embodies" the monolith, the most characteristic space-occupying format of sculpture. But the space-occupying nature of sculpture has two other formats, what I will call the domains of wall and box. The monolith in its most essential form is an upright shaft, a column. But when a column is spread or extended sideways, it becomes a wall, and there its flat, frontal surface conjures forth pictorial art or relief. Add sides to that wall and extend it into depth and sculpture occupies a third format, a compact cube or quasi-architectural box.

Each format leads to each of the others: column spreads to become wall; wall deepens to become box; box elongates to become column. Sculpture is not called upon to fill out each of these formats with solids. For example, while some reliefs are substantial walls, David Smith's *Australia* is one that is open and transparent.

In the late 1950s, like so many sculptors of his generation, Anthony Caro sought escape from the apparent domination of sculpture by the body. But his concern was not just with the body *per se*, but

equally with the monolith format within which it found representation. For him the two were so tied together that they seemed one and the same.

Expression in most figurative sculpture adds to the literal, immobile presence of the column the articulating power of the human body. But by the late 1950s, that power seemed all but exhausted: figurative sculpture was declining into lumpish, unarticulated objecthood. Alternatives lay in the domains of wall and box. Unfortunately, the first of these was complicated by the centuries-long domination of European sculpture by painting. Relief had come to mean pictures, and sculpture was struggling to escape from the domination of pictorial art. In the 1950s, relief offered few opportunities for the ambitious sculptor. The most promising new territory was within the box format, despite the fact that it was occupied by the man-made objects of the world: buildings, furniture, and machines. Because of this it was fraught with peril. The search for expression in that realm entailed the sacrifice of representation and the prospect of the absolute loss of sculptural identity. How could sculpture proclaim itself as sculpture in a world of functional objects? How could it become both expressive in and of itself and sculpturally *real*?

It was not that the body itself was inadequate as a subject — centuries of sculpture had proved otherwise — but since the advent of modernism, the media of both painting and sculpture had inclined more and more to material and method through abstraction from the natural world. In the process, the body as an articulated structure had gradually been detached from the medium. While figure sculpture had enjoyed a brief heyday from about 1880 to 1930, in retrospect the accomplishments of Rodin, Lachaise, Maillol and even Lipchitz appear as a last, hectic flowering of the figurative tradition, a kind of Indian summer brought about by fear of the Modernist future and longing for the Classical past. But despite the heroic efforts of those artists, by the mid 1930s figurative sculpture was in real decline.

During the 1950s Caro was a modeller in this declining tradition, what might be called a "lump modeller" after the fashion of Henry Moore, for whom he worked. "Lump modelling" was not a matter of fine articulation so much as of excessive application. While modelling is by nature an additive method, extreme

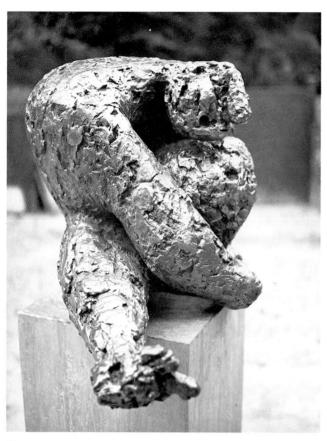

Man Holding his Foot. 1954. Bronze, H 26½'' / 67,3 cm.

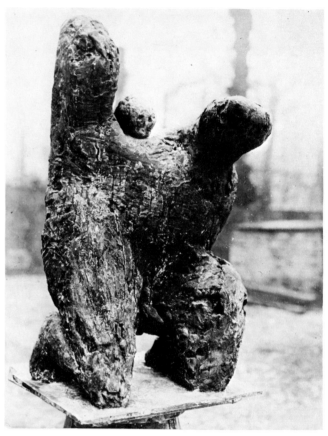

Man Taking off his Shirt. 1955/56. bronze, H 31'' / 78,7 cm.

addition tends to overwhelm it: forms become swollen, and the body loses articulation and is seldom more than sluggishly expressive.

As Michael Fried has suggested, pieces like *Woman Waking Up* and *Man Taking off His Shirt* were attempts by Caro to create a sense of the body being lived in. But the attempts were frustrated by the intractability of the monolith. Lumpishness did little more than illustrate the problem; it failed to discover a solution. Caro needed a new and more flexible medium.

His problem was similar to those that had plagued painters earlier, particularly during the Surrealist phase of the Cubist/Post-Impressionist era. After the first wave of innovation in this century, many painters — among them the Surrealists — sought a language of painting that did not depend on depiction of the external world. Cubism had so flattened pictorial space that traditional depiction no longer sufficed, and they were forced to find a new way to fill out their pictures. Many turned naturally to what they believed was the antithesis of the natural world: the internal world, the

world of the mind. Because most were still attached to illustration, they found in the ''subconscious'' a way to put new wine into old bottles. But they were driven to it not so much by Freud and his discoveries as by the condition of painting itself.

Caro wanted to go beyond simplifying and illustrating within the monolith, but to do that he had to get beyond depiction of the body. It was not that the body resisted abstraction; if anything, it succumbed to abstraction all too easily. The body and its parts broke down readily into simplified ''natural forms'' and these, in turn, asserted the unarticulated monolith. In a sense, this kind of ''abstraction'' was regressive rather than creative.

Caro's transformation is now well known. He visited America in 1959 and returned determined to make a new kind of sculpture. Decisive influences were encounters with American attitudes and working methods, especially those exemplified by his friend, the painter Kenneth Noland. As a result of this stimulus, his work was transformed. Almost overnight it chang-

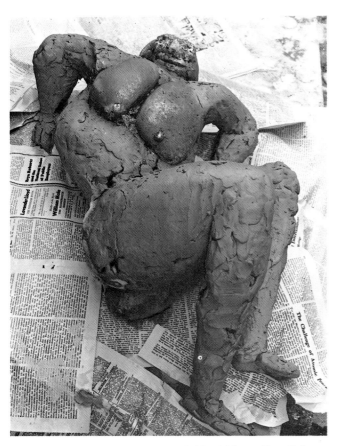

Woman Waking up. 1955. Bronze, H 26'' / 66 cm. Tate Gallery,
London Arts Council of Great Britain.

ed from modelled, figurative sculpture to non-objective,
constructed steel sculpture. But the change of material
was less important than the impulse which led to it.

Caro was by no means the first sculptor to work
in steel. Before him stood Picasso, González, and
Smith. But even Smith (with whose work he was not
yet familiar) stuck to a kind of representation. His art
was abstract after the Cubist and Surrealist fashions
of abstracting *from* nature. But Noland's painting
did not abstract from the shapes of nature at all, and
in this it was radically new. It used purely non-
representational shapes — shapes derived from
geometry rather than nature — and placed them at the
service of colour. His paintings disengaged or disarm-
ed the viewer's tendency to look for visual metaphor.
What metaphor remained functioned apart from the
recognition of shapes. Instead of recognizing or imagin-
ing an image, the viewer discovered an aesthetic ex-
perience that did not refer to nature.

I suspect that Caro responded instinctively to this
new, non-representational and non-abstracting art. The

problems he faced as a sculptor were analogous to
those Noland faced as a painter: to discover a way to
create objects that had expressive articulation apart
from representation. Upon his return to England, Caro
abandoned the monolith altogether, and began to work
within the domains of wall and box. In doing so, he in-
vented a new sculptural language, one of the great
achievements of modern art.

Caro is not the only modernist sculptor who has
undergone a radical transformation, but unlike
predecessors such as Maillol and González he did not
start as a picture maker and did not abandon pictorial
art in favour of sculpture. Nevertheless, his transfor-
mation was more radical. Although Caro abandoned
one sculptural tradition for another, the two traditions
were almost as different from one another as painting
and sculpture. The one he chose was that of
assemblage or construction, a tradition inaugurated by
Picasso, the Russian Constructivists, González, and
Smith.

Assemblage had pursued a fitful and erratic course.
In Smith's hands it became something more definite,
but even there consolidation did not happen overnight.
During the 1930s and 1940s Smith fashioned and forg-
ed his sculpture, often forcing steel to resemble model-
led clay and wax or cast bronze. But in the 1960s he
began to exploit assemblage with found parts in a more
direct way. There, at last, assembled sculpture came
into its own; Smith had virtually transformed it into a
medium. A decade later, Caro took up that medium and
transformed it once again.

Upon his return from America, Caro decided to
make sculpture in a new way, with new materials. He
chose to work in steel, a material with which he had
no previous experience. Taking flat sheets, straight
rods, and I-beams, he attached them to one another
as simply as possible: much of his early work was
bolted together rather than welded. The sculpture that
resulted was radically original and far more non-
objective than the sculpture of David Smith.

Smith's sculpture tends to be anthropomorphic: its
''found'' parts often relate specifically to the parts of
the body. As a result, his sculptures stand on pedestals
and plinths and stamp themselves out like creatures.
But Caro's new sculpture did not symbolize or repre-
sent; the shapes that composed it were just shapes.
It was an art of abstract gestures and positions; one
that occupied space directly on the ground, without
the assistance of pedestal or plinth; a new sculpture
that aspired to ''the condition of music''.

The new language

The simplicity of *Twenty-Four Hours*, Caro's first steel sculpture, belies its revolutionary character. The entire sculpture, constructed from three flat sheets of steel, sits directly on the floor unassisted by pedestal or plinth. The three plates do not represent or symbolize anything, nor do they suggest the functional geometry of architecture; but they do impose a movement through the piece which runs from front to back rather than up and down. This lateral development became characteristic of Caro's work throughout the 1960s; in many cases it literally transformed the wall into a box. This movement is emphasized by the backward tilt of a narrow rectangular plate at the back of the piece; neither post nor anchor, it resists the passive perpendicularity of architecture and enables the overall configuration to avoid the pyramidal compactness of traditional sculpture. *Twenty-Four Hours* is a new kind of sculptural arrangement, a kind of enormously deepened relief, detached altogether from the wall. As a result, it occupies space within the box format. This detachment from the wall produces a new relation between sculpture and ground. *Twenty-Four Hours* stands alone in a new way, achieving the expressive presence of sculpture without having to rely on pedestal or plinth.

Despite its originality, *Twenty-Four Hours* was no more than a beginning. Because from the side view its attachments were not fully integrated, it was frontal by default. Caro's next work, *Second Sculpture*, avoided the problem of attachment by compressing all the elements onto more or less the same plane. After that, *Capital* lifted, spread and tilted the planes, but its attachments were visible once again.

The problem of attachment vanished in *Midday*, a sprawling, utterly original sculpture based on a crude, tilted platform fashioned with rough cuts and held together by heavy and prominent bolts which decorate and punctuate as well as attach.

Like many of the sculptures which followed, *Midday* has a narrow front and a long profile. Laterally it spreads much further than *Twenty-Four Hours*, but overcomes that sculpture's problems of attachment because its platform is such a central expressive feature. The platform dominates like the tilted table tops in Cubist still-life painting. Upon that platform dance three great I-beams: the first and lowest is squared into the channel; the middle one is tilted on

edge; while the culminating one, at right angles to the first, is a complex of three I-beams, the topmost of which, like the back rectangle in *Midday*, tilts back.

The "dancing" I-beams point to a substantial difference between Caro's sculptural elements and those in the work of predecessors like David Smith. The elements in Caro's sculpture are absolutely detached from external reference. Their dance is suggested by placing and context rather than by representation or symbolism. The I-beams are no more than I-beams; they never suggest heads and arms. The entire sculpture is a composition of literal things which have been unified into a single expressive thing.

The Horse, also composed of steel beams studded with bolts, is a sculpture in two parts, reminiscent of Michelangelo's *Creation of Adam* in the Sistine Chapel. Two physically separated sections of the sculpture almost touch. Perhaps Michelangelo had an advantage in displaying his conception on a flat surface instead of via a pair of real objects. *The Horse* may be a bit too close to a demostration to be an entirely successful sculpture.

Lock places studded I-beams beneath a horizontal bar, and thus below the primary reference for the piece. By doing a kind of frozen "limbo", it stakes out new territory for sculpture.

A long horizontal beam also dominates *Sculpture Three* of 1961. It recalls the upright, central spine that dominates so many sculptures by González and Smith. In their sculpture, the spine functions as both reference and support. It is a central, upright, anthropomorphic armature, whereas the horizontal beam in Caro's sculpture reflects and abstracts from the ground; it does not necessarily support.

During the 1960s Caro made many sculptures containing dominant horizontal elements, and they came to typify his sculptural method. In supporting themselves directly on the ground, his sculptures also developed a new vocabulary of sculptural support. The supports in Caro sculpture tend to differ from one another. Because of this, one often cannot tell which elements support and which simply embellish, but one can see that both kinds of element relate to the suspended horizontal, which pulls the other parts of the sculpture into its own visual orbit and away from subservience to the ground. Consequently, its attendant shapes appear to lack support and look

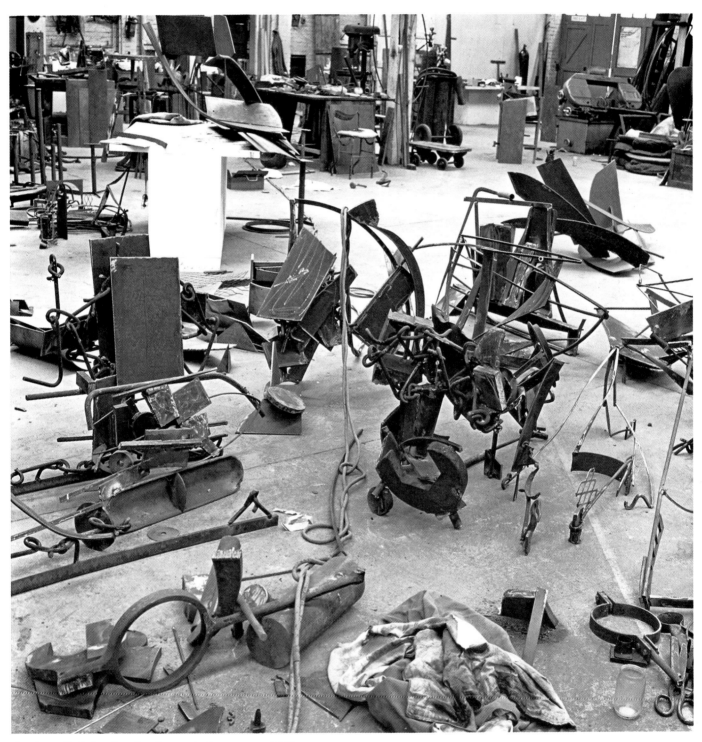

Caro's studio in London showing works in progress. 1978.

weightless. This characteristic is enhanced by painted surfaces which conceal the substance of the material.

Ironically, Caro's floor-bound steel sculptures of the 1960s seem infinitely more weightless than Alexander Calder's mobiles, which hang lightly (at best), but by no means weightlessly, from wires. The weightlessness of Caro's sculpture in this period was essential to its sculptural presence. It transformed the works into self-contained expressive objects which stand upon, but seemingly apart from, the ground. When support becomes too obvious and weight becomes apparent, the sculptures sometimes fail to cohere.

Hop Scotch — a framework of aluminium rods and corrugated sheets — multiplies horizontals into a large, space-consuming network. It is a large, cage-like structure which recalls pictorial art. In this it resembles geometric abstract painting, significantly the late works of Mondrian rather than Noland. But it possesses a scale and casual attitude that go beyond Mondrian and the Bauhaus to suggest the syncopated interlaces of Jackson Pollock. Because the correlation between structure and function has been abandoned, the sculpture holds itself up without any sense of rigidity.

Sculpture Two takes up the two-section notion of *The Horse* but links the sections into a single sculpture. One section is tilted and lifted, but the larger part, dominated by a long beam, runs along the ground. All the elements vary in configuration, positioning and scale; no two are the same. This dissimilarity contributes to the sculpture's unity. The work is sleek, well-finished, and elegant, without rough cuts and rows of bolts, a characteristic which remained with Caro thereafter.

Early One Morning is the quintessential masterpiece of this period. An enormous, yet intimate work, it is too delicate for siting outdoors, and can only be accommodated by a very large room. It is also the first — and one of the most successful — architectural-scale pieces Caro produced during the 1960s. By this I do not mean to suggest that *Early One Morning, After Summer, Prairie*, and *Deep North* are buildings rather than sculptures. They are neither functional nor building-like and boxed in. What gives them architectural scale is not their large size, but the way their size — and the size of their parts — relates to human scale. Each sculpture exploits absolute scale rather than relative scale. It is as if Caro were abstracting the elements of architecture at or near the scale of architecture. Their parts do not just relate to one another internally, but insist, through their scale, on relating in a quasi-architectural way to the spectator[1].

(1) This accounts for why the best of these sculptures — *Early One Morning* and *Deep North* — are so difficult to photograph. Although it can record the relations of parts apart from scale with reasonable accuracy, the photograph can't capture absolute sculptural scale with any precision.

Distillation

In 1964 and 1965, Caro worked in America while a visiting faculty member at Bennington College in Vermont. There he became closely associated with the painters Kenneth Noland and Jules Olitski, and grew familiar, at last, with the sculpture of David Smith. He was impressed once again with American working methods and attitudes, above all with the American willingness to simplify and work in series. In this situation, Caro became extremely interested in a kind of logical reduction. His sculpture from this period seems reduced to bare essentials in a manner similar to the reduction which was occurring in the contemporary paintings of Noland and Olitski.

Caro's American sculptures from 1964 and 1965 are probably the simplest works of art he has ever made and the closest, in this respect, to the tenets of Minimal art. But how different from Minimalism they are, and how much beyond its powers! Caro's simplicity seems even farther from Minimalism than Noland's and Olitski's. Minimal art simplified by creating and multiplying simple geometrical volumes. Instead of composing *within* the box format, it tended to take over the box as a literal thing, as a kind of archetypal sculptural form. In its hands, the box became a truncated monolith or a large, quasi-architectural volume which suggested unfulfilled function. Caro, however, had altogether abandoned the enclosed volume along with the monolith, and was working in a new way *within* the space-occupying and space-containing parameters of the box. No matter how stripped down Caro's

sculpture became, it never assumed the deadpan obviousness of Donald Judd's, Tony Smith's, or Carl Andre's. While the parts in Caro's sculpture were simple and often geometric, they were never boxlike volumes. Caro's pieces of the early 1950s are like three-dimensional runes. They tend to signify and evoke, whereas Minimal sculpture simply asserts its presence.

To put it another way, Caro's art is a matter of abstract gestures and inflections rather than blunt demonstrations. Despite its scale, it flourishes best in interior spaces. In comparison, Minimal sculpture achieves much of its impact from its mute, inexplicable presence. In this it is an offshoot of Surrealism: its presence in any environment — partly because of its large size — seems inexplicably out of context.

Caro's sculpture from this first American period is reduced in a special sense, one that recalls the method expounded by Sherlock Holmes in Conan Doyle's *The Blanched Soldier*. It "starts upon the supposition that when you have eliminated all that which is impossible, then whatever remains, however improbable, must be the truth." Caro's sculptures from 1964 and 1965 are not so much assembled from simplified forms, as appearing to be the radically simple things and relations which remain after everything inessential has been stripped away. They are distillations of the essential elements of a new sculptural language.

This unadorned essence is nowhere more extreme than in *Sight*. The sculpture consists of two simple elements: a short, cylindrical section flat on the ground supports a long, rising length of channel. But, despite its extreme reduction, *Sight* is not geometric and architectural like Minimal art. Its long "upright" inclines away from the vertical, and this separates it from architecture and claims it for sculpture. While *Sight* is by no means a masterpiece, the point it makes is simple but important, and foreshadows the huge sloping plates in the "Flats" a decade later.

A similar reduction can be found in *Smoulder*. Again, it would be impossible to mistake the work for architecture or furniture.

A long, thin bar also appears in *Pulse*, presenting the dominant horizontal in its most distilled form. Resting across two tilted, Z-shaped elements, it seems to float and, through attachment, to render weightless its own supports. In this it foreshadows *Prairie* of 1967.

Two of the larger sculptures from this series, *Bennington* and *Titan*, replace supporting and supported elements with a kind of equivalence more akin to figure and ground. Repeated identical I-beams and swastika-like elements lean against long, low, upright plates, all of which rest directly on the ground. The elements of these sculptures are differentiated in a new, non-architectonic way: supporting and supported parts cease to exist, and functional relations have been replaced entirely by visual ones.

Wide, which comes from an English interval during Caro's first American sojourn, points to this difference. Stripped down though it is, it has not the same air of assertion and declaration as *Sight, Pulse*, or *Titan*. But while it is less single-minded, it more than compensates by the delicacy of its linear display. During the 1960s, Caro frequently used thin, straight elements, often parallel to one another, to suggest a transparent plane. Here steel tubes and channel unfold in a tilted, fan-like arrangement against a short, horizontal base plate.

A more complex variant on this theme is *Span*, from 1966, a masterpiece of attached detachment. Its parts barely graze one another, yet strive to hold themselves and the sculpture upright together.

Another series of sculptures relating to the first American period use transparent planes of steel mesh to explore other aspects of sculptural reduction. *The Window* and *Source* (both made in England) enclose a kind of unenterable room and are as close to straightforward delineation of the architectural box that Caro was to get in the 1960s. But their contained spaces are stripped of function; they are enclosed against eyesight rather than for use. In this they provide a three-dimensional equivalent of the optical space in Noland's and Olitski's thinly stained Colour Field paintings.

Caro's first working sojourn in America set a precedent; subsequently he worked part of each year "on location", mostly in America. The fact that his American sculpture from the 1960s and early 1970s tends to be simpler and more direct than his English work suggests that Caro is extraordinarily attuned to his working conditions.

One of these conditions, the practice of working with assistants, was consolidated in America. Whether his assistants were professional welders, sculpture students, or young, practising sculptors, they inevitably became participants in his sculptural process rather than mere labourers or mechanics. Caro is a uniquely social practitioner of sculpture. He prefers to work with others and welcomes the input of sympathetic assistants attuned to his sensibility and his working method.

Off the table

During the early 1960s, Anthony Caro consistently produced successful sculpture on a large scale. In this he was something of an anomaly. Since Michelangelo's time in Western sculpture, the medium has resisted large size. Larger than life-size sculpture tends to look puffed up, and even life-size sculpture has rarely been as successful as small, hand-modelled bronzes. Even great sculptors such as Rodin, Maillol, and Lipchitz were often most successful in their small and mid-size works.

Caro's new indoor constructive sculpture not only demanded large floor spaces, but rejected placement on table tops and pedestals. It also resisted reduction: a small version of *Midday* or *Early One Morning* would look like a model or miniature on a table top; in that context its scale wouldn't be specific.

But Caro was worried about more than finding a new way to work small. The problems that challenged him in the early 1960s had been solved. A new language had been fashioned, but he now feared that inspiration might give way to formula. He was one of the first artists of his generation to fear that the appearance of radicalism might threaten its substance, and one of the first to seek a new challenge in the past. He looked for it in the pedestal, from which his new sculpture had wrested its freedom with so much difficulty only six years before. There, it seemed, his new language was not yet able to speak.

Traditionally, small pedestal sculpture was cast in bronze from clay or wax originals. Because it was usually modelled rather than carved, specific scale was supplied by touch, by the human hand. But because Caro's new sculpture didn't exploit touch, he was faced with the problem of making small scale specific in a new way. He found a solution by appropriating two things from the world of everyday objects: the table edge and "found" tool handles.

The table edge was a non-material abstraction from the horizontal beam in sculptures like *Early One Morning*. By spilling over the table edge instead of sitting directly on its surface, Caro's "Table Pieces" related to the one aspect of the table's surface that it didn't share with the ground. The table edge became a horizontal reference akin to the contained horizontal in so many of his larger pieces[2].

The handles related to human hands and thereby made the scale specific: a small piece containing a handle could not be a smaller version of a larger work. But, while these tool handles were the first identifiable "found" objects Caro used, their presence in his sculpture seldom led to anthropomorphism. He used them simply as shapes, although a new kind of allusiveness began to assert itself as the pieces gained in complexity. This was true, especially in the beginning, when he used the handles of scissors, which combine a kind of "industrial" modelling with a cursive profile. This new assertiveness of found parts pointed towards his great found-part sculptures of the 1970s and 1980s.

In one of the very early, chrome-plated "Table Pieces", *Table Piece XIV*, a solid bar, square in section, joins an upright plate to the table. The incorporation of a non-material abstract part, the edge of the table, into the sculpture tends to dematerialize the other parts. As in the larger works, dematerialization leads to unity.

These early "Table Pieces" were chrome plated. Chromium tended to "distance" the tactility of the handles and was a surrogate for the painted surfaces of the larger floor sculptures. In addition to concealing the steel, it added a jewel-like finish, in keeping with the new sculpture's small scale. But chrome plating did not last for long in Caro's art. As the "table pieces" enlarged and gained in complexity, he found that specific scale could be provided by the parts in relation to the table edge alone and, later, to the sculpture's configuration in itself. Tool handles were soon abandoned and he painted the "Table Pieces" until the end of the decade.

Like his large, linear sculptures, especially the radically reduced works of 1964-65, the chrome-plated "Table Pieces" are quintessentially sculptures of the 1960s. In them, Caro exploited linear elements in a new, declarative way. For example, the lines in *Table Piece XIV* do not draw around or contain space any more than do the lines and planes in *Early One Morning*. Instead, they occupy space as thin, declarative substances.

But Caro soon began to experiment with complex configurations which threatened to compromise the spare sculptural language he'd worked so hard to invent. For example, while *Table Piece XXXVII* seems

(2) Both the use of the table edge and the tool handles were suggested by Michael Fried.

to look back to the 1950s, it also, as backward-looking art often does, looks forward. While its "dancing scissors" recall David Smith's use of found parts, the framework which holds them together is Caro's own. It is an abstract frame, filled with inherently evocative elements, which sits at right angles to the table.

Curves began to assert themselves in Caro's sculpture in 1968, not as circular motifs like the shield shape in *After Summer*, but as fundamental elements of the sculptural structure. In *Table Piece LIX*, curved lines do more than simply, establish positions; they now imply movement. The sculptures with curves in them unfold, writhe, and contain. For example, the most complex "Table Piece" of 1968 is *Table Piece LXIV (The Clock)*. The sculpture exploits a complex "C" shape which bites the table edge. In fact, the whole sculpture is an inspired accumulation of curves and straights, of extended cursive elements and staccato linear attachments.

The inspiration for *Table Piece LXXXVIII (Deluge)* came from the Leonardo drawings in the collection of Her Majesty the Queen in London. Baroque in its complexity, the work is a masterpiece of curvilinear drawing pushed to the brink of excess. While it is a far cry from the spare, stripped-down character of some of Caro's earlier work, it derives from that sculpture insofar as taking away depends upon prior addition. Thereafter, one of Caro's most characteristic working methods would involve overloading a sculpture in order to edit an eccentrically simpler one from it.

Since 1966, Caro has continued to produce "Table Pieces" as well as other small sculptures. While the former continued to spill over table edges until the mid 1970s, his small sculpture has always related closely to his larger work. He has continually made small sculptures at the same time as large ones, and has consistently carried ideas from large sculptures to small as well as from small to large. Nevertheless, because small sculptures can be like quick sketches, they have often provided Caro with a staging ground for new ideas.

By allowing him to work swiftly and easily with light materials, working small has added enormous flexibility to Caro's working method. Most of the "Table Pieces" are made in the garage at Caro's home in London and are worked at again months later in his studio. This long delay is as important to Caro as the initial "sketching out"; it provides for detached reworking, away from the heat of inspiration; long absence makes it easier for Caro to see his work with fresh eyes and, for him, seeing anything afresh is vital.

Culmination

A column spreading to become a wall is essentially a line spreading to become a plane, and thus the horizontal bars in Caro's large sculpture spread to become table tops. Given the conditions of Caro's development, this new internalized horizontal was inevitable, but it was only one of many influences carried over from small sculpture to large that preoccupied Caro during the late 1960s.

Despite the table top's inevitability, it proved curiously resistant to sculptural treatment. Caro attempted it first in *Trefoil*, but there it seems arbitrary, the platform seemingly pierced by arrow-like verticals which balance, above and below it, upon their points. The implied table top in *Prairie* is very different.

One of the most famous sculptures of the 1960s, *Prairie* recalls sculptures surmounted by horizontal bars like *Lock* of 1962 and especially *Flats* and *Pulse* from 1964. *Prairie* is a quintessential Caro sculpture. Its four horizontal bars surmount underpinnings that dissemble their function as support. The sculpture aims to create a floating, illusory plane in terms of absolute scale but, despite the brilliance of its conception, it succeeds more as a demonstration and recapitulation than as an inspired work of art. It is something of a set piece, a bit too large for what it intends and fashioned too rigidly on the square.

Although it does not contain a table top, *After Summer*, from 1968, seems equally beholden to the "Table Pieces". Its opposing pairs of huge, sectioned tank ends spill, like giant petals, over both sides of a long, double track. Also conceived in terms of absolute scale, this sculpture seems inspired equally by the railroad and the cathedral. But sculpture lacks the ability of architecture to separate the experience of interior

from that of exterior. *After Summer's* massive solidity can't approximate to the grand interior surfaces that are so powerfully expressive in Gothic architecture. And while the allusion to the railroad may be unintentional, it is no less unfortunate. The rails fail to match or complement the expressiveness of the giant petals. They exist primarily to hold them apart and upright.

In both *Prairie* and *After Summer* Caro seems to have misjudged scale, aiming for the absolute scale of architecture when relative scale would have been more appropriate. Both seem undermined by their huge size. They lack the lightness and grace of *Early One Morning* and have not yet reached the complex expressive

means of *Deep North*. Perhaps this explains why they photograph so well: in reproduction they appear smaller than they actually are.

But Caro was by no means at an impasse. *Argentine*, from 1968, discovered a solution. Developed out of the contemporaneous "Table Pieces", it spreads and sprawls, an unfolding complex of curves and sectioned tank ends. And this unfolding leads to the abandonment of Caro's characteristic horizontal axis. Ironically, while the "Table Pieces" had been suggested by that reference, they in turn suggested an alternative to it: *Argentine* spills across the ground the way many of the table pieces spilled over table edges.

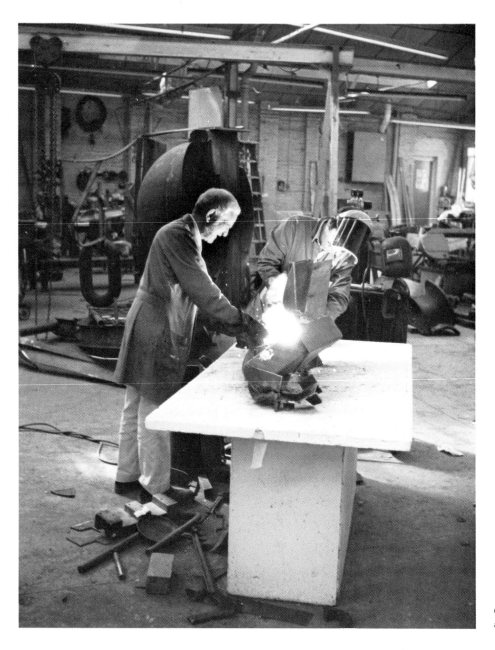

Caro in his London studio, with assistant Pat Cunningham. 1984.

In abandoning the internalized dominant plate or beam, *Argentine* places a new pressure on drawing. For the first time in one of Caro's large pieces the sculpture exploits the organizing power of its own contour. This led to a new freedom.

The crowning glories of Caro's 1960s art came in 1969 and 1970 with *Orangerie, Sun Feast*, and *Deep North*. The three sculptures also exploit various elaborations of the curve explored earlier in *Table Piece LXIV (The Clock), Argentine*, and *Trefoil*. Among these are propeller blades and ploughshares, both twisted planes. At once a plane and not a plane, each element continually presents a new surface as the viewer moves around it. Because of this, they become at once the most evanescent and three-dimensional of sculptural shapes.

Orangerie is a still life in the round. Its twisting planes and curving lines above and below an eye-level table top impart an uncanny sense of shifting relations among the sculpture's parts. It is a kind of fixed ''mobile'', but one which possesses a combination of stability and internal movement that far surpasses anything achieved by Calder.

One of the great masterpieces of modern art, *Sun Feast* is a complex and compressed culmination of a vein which began with *Sculpture Three* of 1961, almost ten years before, the last and greatest of Caro's sculptures which contains an internal horizontal ''reference''. In this case the reference is a high platform, close enough to eye level to make it almost an edge. The sculpture presents a combination of strong profiles (disks and flat plates) and evanescent ones (a high table and twisting planes).

From the same period as *Sun Feast, Deep North* is a culmination of a more radical kind; one of the most unusual configurations in sculpture of any kind. Like so many Caro sculptures, it develops from one end to the other: at the back, curving, containing elements and a short horizontal; in the middle, an enormous, twisting column made of upright propeller blades; and at the front, a cantilevered grate. Huge curving planes contain floor space between the central column and the back, while the grate floats ominously above it at the other. In this it is the culmination of a direction which began with *Early One Morning* in 1962. Like *Early One Morning*, its structure plays with the scale of architecture. It uses the absolute relation between its parts and the scale of the human body to create a coherent and unifying effect apart from its simple configuration, which is a somewhat surreal juxtaposition of incongruous elements. Because of this, the experience of *Deep North* is even more resistant to photography than most works by Caro. Nevertheless, its expressive effect differs enormously from *Early One Morning*. Its absolute scale is reinforced by asymmetry, which enhances its sense of instability yet ties the whole configuration together. The unity of *Deep North* is as perilous as its configuration. It takes the major elements of Caro's 1960s vocabulary to a point beyond which he could develop them no further.

Materialism

Caro's sculpture from the 1960s tended to be open, linear, and painted. He had a unique ability to compose with long, straight rods and planes that both penetrated and occupied space. In this his art went against accepted sculptural practice, in which projections, whether arms or finials, seldom lead outside a strong, overall contour. Caro's sculpture depended far more on related positions.

In 1970, this aspect of Caro's art changed radically. *The Bull,* made immediately after the André Emmerich Gallery exhibition which included *Deep North, Orangerie*, and *Sun Feast*, exemplifies this transformation. In a sense, the sculpture recalls and revises *Sun Feast*. Both sculptures exploit circular elements in relation to a strong horizontal, and each has a flat end plate at right angles to its horizontal development. Although *The Bull* is much simpler than *Sun Feast*, its horizontal ''spine'' is more strongly characterized: where *Sun Feast* has a neutral platform embellished with curved planes, the ''spine'' of *The Bull* contains its own embellishment, formed from thick offcut ''found'' elements with semicircles cut from them. While *The Bull* exploits different aspects of semicircles, this is only one aspect of a more basic reorientation: in this work there is less emphasis on the positioning of neutral parts and much more on their specific character, as

well as on the sculpture's overall contour. Because of this, *The Bull* is much more immediate and physical than *Sun Feast*.

It seems to pick up where *Twenty-Four Hours* left off a decade earlier. In so doing it announces Caro's sculpture of the 1970s, which is given over in a variety of ways to contour and materiality. Caro began by rediscovering the materiality of steel and the strongly characterized qualities of steel scrap, something he had avoided during the 1960s in order to steer clear of anthropomorphism. However, by 1970, as *The Bull*'s title suggests, anthropomorphism had ceased to be an issue. Perhaps the extreme abstract presence of *Deep North* and *Sun Feast* had made it redundant.

But a new danger came from within. *The Bull* threatened to undermine the sculptural medium which Caro had, himself, fashioned and had just brought to a triumphant culmination. *The Bull* "sets" itself simply and directly, much more directly than had *Prairie*, for example, which fought to transcend its material and its scale. By the end of 1960s, it appeared, only a Herculean conception like *Deep North* could accomplish that. And that accomplishment was a kind of ultimate in its own terms, beyond which Caro's sculpture could not develop expressively. *The Bull* is at once more traditional and more radical than Caro's 1960s sculpture: raw, unpainted steel asserts itself for the first time, and with it enters materiality, weight, and a strong, enclosing contour.

Picket, a small sculpture from this series, is a masterpiece of demonstration transcended. Four cross-saped offcuts seemingly descend step by step into the floor, establishing the floor plane as a dominant and unifying horizontal. This descending order is more than a trick. It uses the ground as a reference in a fashion that recalls the table edges of the "table pieces", only in this case the ground itself becomes ineffable and absolute: a barrier seemingly penetrated by the sculpture and a plane which determines where the sculpture begins. *Picket*'s poetry is in its relentless quarrel with the ground.

Canal, too, is direct in a new way. Whereas *The Bull* draws simple strength from the blunt assertion of right angles (lateral movements against full, perpendicular stops), *Canal* adds a twist, an abstract contrapposto. I don't mean to suggest that Caro's earlier sculpture was all a matter of right angles, but departures were usually placed against a single dominating element, usually a horizontal bar or edge. While *Canal* is composed primarily of horizontal elements, no single element dominates.

This new equivalence of parts characterizes many sculptures from 1971, among them *Bailey, Side Step* and *Paul's Turn*. It is exploited differently in the ruthlessly rectangular *Ordnance*, which looks back, after a fashion, to *The Bull* but, coming after *Canal*, has a much greater equivalence of parts. *Ordnance* is about as close to Minimalism as Caro was to come. Essentially it is a large cage or floor-bound room, a massive, aggressive, and forbidding four-square piece. While it contains a quasi-architectural space, unlike *Source* and *Carriage*, it doesn't define that space through lyrical inflections, but encloses and guards it aggressively. In contrast, *Cherry Fair* is tilted, lyrical, and painted, but original nonetheless. It features enormous contrasts of scale, a cluster of linear elements spinning up and out on a tilted plane, like the plane of the ecliptic.

Caro started using steel for its own qualities, emphasizing its weight and unadorned surface, in 1970. Prior to that, thickness *per se* hadn't been an issue so much as had shape and sectional configuration (square, cylinder, I-beam, channel, angle, etc.). Now steel led to other materials: clay, bronze, silver, paper, and lead, but first of all via stainless steel.

The stainless steel came from David Smith's stockpile of materials, which Caro acquired from the Smith estate. In using the material, Caro was faced with a double challenge: to use elements of Smith's vocabulary in his own way and to deal with the relative intractability of stainless steel which, because it can't be flame cut like mild steel, must be used more or less as found. His solution was not to use strongly characterized found parts, but to combine elements into new, complex shapes, for example the concave diamonds of *Cool Deck* or the square composed of two diagonal offcuts in *Box Piece F*.

Cool Deck takes the new interest in materials a step further. Caro's largest stainless steel piece, it consists of a cluster of concave diamonds played off against crossed rods and attached plates. It spreads out on the floor and, while it is by no means the first low-profile Caro, it is his first really low-slung sculpture to open *against* the ground. In this it recalls Giacometti's *Woman With Her Throat Cut*, an earlier sculpture with its back to the floor. Both *The Bull* and *Picket* suggest that Caro was preoccupied by a new kind of relation of his sculpture to the ground. But to turn a sculpture's back to the floor by entirely abstract means is a *tour de force*.

Straight Up and *Straight On* are two of a series which share a common idea (the "life" or "death" of

the H-beam motif) as well as a common word in their titles. They are more than variations on a theme: each work in the series is "edited" from a single, larger sculpture. *Straight Cut*, for example, is the bottom half of *Straight On*.

The "Straight" appellation was the first time Caro used a word or phrase to characterize a series, a practice which he continued to exploit thereafter. The practice is not significant in itself, but it does reflect Caro's new preoccupation with working in series — often delimited by location and the nature of available materials. Between *The Bull* and the "Straights", Caro worked in a variety of ways, as if he were casting about for a theme and a new method of working. The "Straights" were a step in that direction. In the "Flats", which followed, the direction was found.

Flats

In 1972, with the assistance of James Wolfe, Caro made fourteen large sculptures in two weeks at the Rigamonte factory in Veduggio, Italy. The magnitude of this and later accomplishments (especially at York Steel in Toronto) suggests a comparison with David Smith at Voltri, Italy, a decade earlier. Caro was certainly familiar with Smith's accomplishment, and may have been challenged by it to work on location. But the comparison reveals something more important still. By 1972, Caro was used to working on location. His accumulated experience made it possible to work quickly and in series; his new interest in material caused him to be challenged by the different characteristics of steel. The stage was set for a breakthrough.

Veduggio provided the stimulus with a new kind of steel scrap: cast off, contoured ends of milled sheet steel, which were to dominate Caro's sculpture, both large and small, for more than two years. The contoured and sometimes waving surfaces of these sheets are formed when the steel is extruded from the mill in a hot, plastic state. (These mill ends are normally cut from the steel and remelted as scrap.) The sheets had a moulded, plastic character, like huge uncut clay slabs, yet retained all the properties of steel. Many of them were square-profile rectangles with a ragged or waving leading edge; others, especially from Veduggio, were narrow horizontals, cut close to the undulant, leading edge. Because these shapes lacked geometric profiles (at least at their leading edge), they suggested some of the properties of amorphous, modelled sculpture — the sculpture of Arp and Moore. In a sense they looked like Henry Moore sculptures rolled flat.

Caro exploited these contoured slabs by combining them into three-dimensional collages. He created huge walls, gates, and platforms, often with soft, quasi-figurative upper edges. In so doing, his work took on an entirely new character, one remarkably close to architecture and to abstract painting, especially to the allover paintings of Jules Olitski. (Coincidentally, in the early 1970s Olitski was exploring a new materialism and plasticity in his painting.)

Veduggio Sun, an outstanding work in the series, is both wall and gate, has both external and internal contours, its flat, wall-like profile "contained" by comparatively small sections of channel on the floor. *Veduggio Plain* is an abstract space, established at bottom and back as floor and wall, with an undulating intrusion where they join.

The "Veduggio" series was rather linear and graceful, curiously in keeping with the elegant Italian steel. The next group, made in England in 1973-74 with steel acquired from Durham, was heftier, and exploited the sheet more directly still.

Durham Purse, for example, is a graceful steel envelope with a waving, horizontal extension, the straight bottom edge of which cuts a right angle against the vertical front of the envelope. The sculpture is a kind of container anchored by an elevated, horizontal edge. This is one of the few flats which, like Caro's sculpture of the 1960s, has a long side and a narrow front. In this, it is farther from relief than most of the other "Flats".

Durham Steel Flat, perhaps the best work in the series, takes the form of an enormous upside-down sheet (contour to the bottom) supported on a kind of giant sawhorse. It comes closer to painting than any prior sculpture of Caro's, yet it remains curiously distant from relief. The sheet is tilted just enough to remove it from association with the wall, and its only relief element, a steel ring welded high on the surface

of the sheet, contrives to enhance the immediacy — the *sculptural* immediacy — of the entire object.

Curtain Road is a leaning, sprawling piece, its huge, leaning sheet framed, interrupted, and virtually surrounded by narrow ''contours''.

After the ''Durham'' series, Caro produced the massive ''Flats'' series at York Steel in Toronto, Canada, with thicker, large plates. These had the character of gigantic collage, if only because the slabs were flatter and more immediate still. In the Canadian ''Flats'' the very substance of the sheets gave sculptural immediacy to configurations which, on a smaller scale, might have appeared thin and flimsy.

The ''Flats'' are the culmination of a direction which began with *The Bull*. They represent an extreme alternative to Caro's outflung sculptures of the 1960s. They gather in. They exploit large, flat planes, whereas his 1960s work pierced open spaces. Contour in them counts for much more, as does the physical immediacy of sheet steel.

On the table

Caro's table sculpture always reflected and influenced his larger work, but in the 1970s the relation between the two became even more direct. Many small sculptures, for example, reflected Caro's preoccupations with the ''Flats''. In fact, in addition to using small rolled ends, Caro sometimes cut the contours of his small sculptures in waving shapes similar to the strong mill-end profiles from Veduggio, Durham, and York Steel.

Nevertheless, it is surprising how long it took for his table sculpture to escape from the table edge, which was so characteristic of his 1960s vocabulary. No matter how much his small sculpture reflected his ''larger'' concerns, it clung to the table edge until 1975.

This is not to deny the quality of some five years of table sculpture. Perhaps working with planes and contours was so liberating in itself that the frontality imposed by the table edge simply was not an issue. In any event, Caro produced many successful pieces, among them *Table Piece CXVI, Table Piece CXXXVII*, and *Table Piece CLIV*. Towards 1974, though, the configurations of the ''Table Pieces'' often fought with the table edge, as if they were complicated by one contour too many.

Sometimes they made a display of hanging below the table edge. *Table Piece CC* of 1974 makes something outlandishly inventive of that display by suspending a long looping horizontal. But *Table Piece CCIII*, which follows close upon it, develops the idea further by ignoring the edge altogether and raising, instead of dropping, the looping horizontal. It is no longer confined to a frontal view and gains the freedom of sculpture in-the-round. Because of this, perhaps, it seems more self-contained.

Although *Table Piece CC* was by no means the last off-the-table small sculpture, its companion rang the death knell of the series. By 1975, Caro's small sculpture occupied table tops and floors with grace and ease; so naturally, in fact, that the transition from table edge to table top is scarcely apparent. It was ''in the blood'' before it was fully realized.

In 1974 and 1975 the upright ''Table Pieces'' gradually moved away from the flat planes of the ''Flats''. The planes were replaced by narrow, tapered, and undulating strips, and soon this undulating drawing began, itself, to delineate contours. In this it differed from the linear drawing of Caro's 1960s table sculpture, which had tended, even in a complex work like *Table Piece XCI (The Deluge)*, to mark positions. For example, the two arcs in *Table Piece CCXLVII* describe an outer edge. Circles (contained shapes *par excellence*) became more and more insistent until, in the magnificent *Table Piece CCLXXX*, a circle with contained, jagged drawing makes up a large portion of the piece.

Caro's new on-the-table sculpture was important in several respects. In a lasting sense, it obliterated the distinction in kind between his table sculpture and free-standing work. Thereafter, Caro's sculpture moved much more easily between table and floor. But its more immediate influence was no less important. It had ceased to follow the lead of his larger, free-standing work and, with its complex, linear contours, was once again in a position to lead the way. The free-standing sculpture soon followed.

Drawing around

The steel plates in the "Flats" gradually thickened as Caro progressed from one series to the next. As we have seen, the Canadian "Flats" were thicker than the "Durham" and "Veduggio" series that preceded them. In 1975 and 1976 he pursued this still further in a series of sculptures that included massive thicknesses, as if he wanted the very weight and substance of steel to convey a kind of primordial sculptural expression. For example, *Caramel*, from 1975, has a thick, tilted plate which seems willed into stratified flatness. Yet Caro went beyond even that. By 1976, sculptures like *Nectarine* were compromised by the amorphous tactility of massive steel insertions. Caro found himself, once again, at one of the limits of sculptural expression.

Instead of retreating, he tackled the problem of massive elements from another angle. *Slide Left, Dumbfound*, and *Midnight Gap* contain clusters of short steel cylinders, bars, and plates (similar to sectioned elements in the contemporary sculpture of Tim Scott) within contexts suggested by the "Flats", his table sculpture, and his sculpture of the 1960s. Always an additive artist, in this series Caro's working method became additive in the extreme. He welded together conglomerations of bits of steel, and then edited from them until he discovered a kind of clustered order. While the clusters, themselves, are massive, they are rescued from amorphousness by the machined geometry of the sculptural solids which compose them. The clusters become a kind of mechanistic plane.

The cluster of steel in *Slide Left* seems to have been deposited at the lower end of a tilted trough of bent I-beam which is supported, in turn, by a cluster of short, steel bars. In *Dumbfound*, bars and plates accumulate around a tilted, central bar. But *Midnight Gap* is the *tour de force* of the group. Its heavy clusters of sectioned steel and rectangular plates, edited out of an enormously crowded and earlier state, hover like immobile mechanical fruit above a large, tilted geometric plate.

Despite the massiveness of their parts, Caro seemed to be groping, in these pieces, towards a more linear mode, one contrary to the impassive barriers of the "Flats" and closer, in this respect, to his sculpture of the 1960s. Characteristically, he explored this first in table sculpture which, in early 1977, became increasingly open and cursive.

Many of these sculptures feature continuous contours of bent, ribbon-like rods or strips. Their outer contours are varied and frequently change character, shifting from one kind of element to another (for example, from the edge of an internal shape to a cursive rod or strip). As a result, they are emptied out and "open" in a new way. High accomplishments in the series include *Table Piece CCCXIII*, which features repeated, linear drawing and circle motifs held within a loose, quasi-circular contour, and *Table Piece CCCLIV*, which is dominated by an extended S-curve and which trades contours with flat bullet shapes.

While there was no abrupt turning point, the direction was consolidated — so far as large sculptures went — while Caro was again working "on location", this time at the Emma Lake Artists Workshop in Saskatchewan, Canada, where he worked for two weeks during the summer of 1977 with assistance from the Canadian sculptor Douglas Bentham. The "drawings in space" from this series are a far cry from Caro's linear sculptures of the 1960s. Basically, the "Emma" sculptures are cages rather than fences. They don't so much occupy the sculptural "box" format as define it. They are often elaborate "exo-skeletons" that contain space.

Caro's large "Emma" cages are not at all architectural, but neither are they anthropomorphic, except in a tremendously abstract sense. *Emma Dipper*, with its central convergences touching and "locating" the floor unexpectedly, and *Emma Dance*, which inclines to the side as if about to erupt into a rustic dance, are beautiful and entirely original.

The *National Gallery Ledge Piece*, Caro's first major commission, was strongly related to the "Emma" series. It's also interesting because it illustrates Caro's working methods so well and, in the process, indicates why good commissioned sculpture is so rare. Although Caro made a series of preparatory studies in his studio, he did not then make and install an enlarged version of what appeared to be the most suitable. The fact that the scale of the studies was specific meant that they were not really models and could not be enlarged mechanically. (Sculpture which succeeds on a small scale can seldom be enlarged successfully beyond life size, while small models for large work often look pseudo-architectural when enlarged.) Because of this,

Caro decided to construct an entirely unique sculpture *in situ*.

The *Ledge Piece* is a low-slung, elegant construction which rises unexpectedly into the darkest and lowest corner of a second-story niche. It draws upon many facets of Caro's work: a long horizontal at the front and a narrow, upright triangle at the back position themselves and penetrate space somewhat like his 1960s sculpture; the piece spills over the edge of the ledge like a giant ''Table Piece''; and one large, linear circle contains scattered bits of drawing like an open ''cage''. The sculpture exists independently yet remains specific to its site. It is assisted, in this, by the nature of the site which is, of course, unique. Set on the periphery of the East Wing's gigantic central foyer, it is not obliged to compete with the building's almost superhuman scale.

Table Piece CCCC of 1978 is one of the most spare and empty linear pieces from this period. It demonstrates Caro's great mastery of scale, from the small, period-like dot outside one contour, to a suspended square and a large pair of real pincers, which anticipate the pokings and pinchings of the ''Writing Pieces''. It spreads more or less on the plane, after the fashion of Smith's *Australia* and *Hudson River*

Landscape, but it is free standing and essentially more abstract.

The ''Writing Pieces'' of the late 1970s exploit Caro's new cursive drawing and recall, with a new complexity, Caro's linear work of the 1960s. They were painted (by Sheila Girling) and contain recognizable tools — often wrenches, pincers, callipers, and tongs — used not simply to establish scale, as in the 1960s, but to animate each piece. Furthermore, they suggest runes in a new way, often through what appear to be specific references to English words. (Caro never selected the word first. For all their allusiveness, the ''Writing Pieces'' are not illustrations.) On balance, they represent a playful episode in Caro's recent development. But at times their almost comic, anthropomorphic playfulness and two-dimensional development can be intrusive. Frequently callipers, pincers, and tongs span gaps, a practice begun with *Table Piece CCCC*. The effect can be remarkably delicate, like a kind of abstract ''touching''. And because wrenches and pincers have a kind of mouthlike configuration, the ''Writing Pieces'' constantly allude to the voicing of words. In this, too, they recall art from the past; they resemble machines made after the pattern of Paul Klee's *Twittering Machine*.

Clay and bronze

Although its full implications were realized at the time, the ''Can Co'' series of clay sculptures from 1976 became another turning point in Caro's development. The sculptures were produced in America, at Syracuse, New York, as part of a special project sponsored by the University of Syracuse and the Everson Museum. Caro was one of a number of artists, most of them painters, who were asked to work in clay. As few had worked previously with the material, they were provided with technical and physical assistance by Margie Hughto, the project coordinator, and students from Syracuse University.

Caro started by adapting his working method with steel to a material that seemed alien to it. He created a stockpile of prefabricated parts that resembled the found steel he was accustomed to: slabs, wedges, cylinders, and thrown shapes, which he subsequently assembled as much as possible after his practice of

steel construction. Because of this, the sculptures do not depend on the kind of plastic coherence that is characteristic of clay. They are assembled, not modelled. But because assemblage with clay cannot take advantage of the enormous strength of steel and the powerful attachments of welds, they tend to rely on simple piling, leaning, and arrangement. Because of this, they often have a casual, unselfconscious beauty.

Before Caro, the American sculptor Michael Steiner, had worked with clay at Syracuse, and he, too, worked with it much as he previously had with steel.

Clay led Steiner from steel to bronze, and so it led Caro. But Caro's clay experience differed from Steiner's. In the ''Flats'', which frequently exploited the malleable, plastic quality of steel, Caro had anticipated clay: he was already familiar with the plastic character of steel. Because of this, perhaps, his clay sculptures tend not to be as languid and malleable as

Steiner's. There's a Constructivist stiffness in them, something that remains essentially true of Caro in relation to Steiner thereafter. And their constituent parts tend to be more varied and more strongly characterized. (Steiner's parts have always tended to be rather neutral in themselves.) In Caro's clay sculptures, slabs intermix with thrown shapes and prefabricated shapes of other kinds. He found that he could manufacture parts that were as neutral, but as potentially expressive, as found or prefabricated ones, and these led directly to a great series of bronze and brass sculptures.

That series began with a new vocabulary of parts. These are of two kinds. The first is a series of saw-cut brass rods and sheets which are, by nature, geometrical and straight (although thin rods are sometimes bent). They recall the geometrical parts that Caro had used since the early 1960s. The second are cast bronze shapes, some cast from shapes found in other materials and others of Caro's own manufacture. These frequently have an organic character and finish which contrast with the machined character of the brass parts. In this respect they recall the ''soft'' plasticity of the steel that Caro used in the ''Flats'' and to which he returned, in one way or another, throughout the 1970s. But the effect in the bronzes is seldom one of the soft malleability of modelling (although it does occur, for example in the beautiful *Water Street Straddle* from 1980). Generally speaking, a new stiffness prevails, and this is due to the preponderance of vessel shapes among the bronze parts: pipes, tapering cylinders, and an assortment of deep dishes and tubs.

These vessel shapes affected the general character of the pieces, which occupy the ''box'' format more completely than in Caro's work hitherto. In gravitating to the vessel shape as a primary sculptural part and, on occasion, as the dominant configuration of a sculpture, Caro looked to the past, once again, in order to move forward. Vessels have traditionally shifted status between function and art. In the realm of high art, one thinks of Chinese ritual bronzes and the vases and bowls of Tang and Sung. While both the exterior and interior of a clay or bronze vessel are often visible, the interior tends to serve function, while the exterior favours display. Caro removed the functional aspect of the interior altogether by halving and quartering individual shapes and by clustering and tilting them in non-functional configurations. The configurations are not so much clusters of solids as clusters of insides and

outsides, convexities and cavities. Although this was foreshadowed in the tank ends of the late 1960s, especially in the gigantic *After Summer*, in the bronzes it was used with much greater complexity and came to dominate many of the sculptures: they become volumes within volumes, boxes within boxes.

While this clustering and containment was prefigured in many works of the mid 1970s, it was reinforced by the nature of new materials. Because bronze welds are much weaker than steel ones, long cantilevers are impractical. To gain strength, Caro tended to weld parts at two separated points and often resorted to triangulation and consequent clustering of the parts joined. This reinforced the enclosed profiles and boxed-in character of many bronzes.

Clustered shapes dominate *Buddha Peach*, the first of Caro's bronzes. While these recall the clustered solids in *Slide Left* and *Midnight Gap*, in *Buddha Peach* their arrangement appears more worked out, more composed; and the hollow and sometimes tapered shapes have an entirely different presence. *Buddha Peach* stands on three legs, a kind of triangulated support used more frequently in the bronzes than in Caro's earlier art. In addition to reinforcing the interior triangulation, this tends to dissemble the sculpture's frontality. The bronzes more frequently avoid obvious fronts and backs than do the works in many of Caro's earlier series. Front and sides were frequently given by the long horizontals in the 1960s, by flat sheets in the ''Flats'' and by the table edges in the ''Table Pieces'' before 1975. In comparison, the bronzes are often true sculptures in the round.

An extreme kind of clustering occurs in *The Mosque*. In a different way from the ''Emma'' series of 1977 and ''Table Pieces'' like *CCCLXXXVIII*, it recalls Giacometti's *Palace at Four A.M.* It occupies space much more fully than the earlier works. It is thickly clustered and heavily occupied, its space filled more densely and more architecturally than any of its predecessors. As its name suggests, *The Mosque* is as close to architecture and the architectural model as Caro was to get. Despite its density, it is closer in feeling to an architectural model than the open, linear works, much closer than the more container-oriented pieces like *Late Quarter*.

Late Quarter is one of several variants on a simple theme. The title is suggested by the ''quartering'' of one of its two principal elements, a roughly tank-shaped vessel which partly contains the second, a halved horn-like shape. This beautiful sculpture stands apart from Caro's earlier work by its frank acceptance

of the vessel format. In this, and because of its turquoise patina, it recalls a Chinese bronze, but one shorn even of its ritual function.

In the bronzes of the 1980s, the sense of containment is often constructed rather than prefabricated and "found". *Half Dollar, Half Moon, Half and Half,* and *Double Half* use cavities in concave displays and "bookshelf" configurations. Many of the other small and mid-size bronzes build cavities or shallow boxes. Two masterpieces are the beautiful *Water Street Straddle* and *The River*, the former a wide shallow box with a bridge-like centre, the latter reminiscent of one of Picasso's paintings of running bathers.

The "Bronze Screens" of 1981 exchange concavity for convexity, and mark Caro's exploration of a new kind of uprightness. They are free-standing wall pieces constructed against the wall. Although they use the wall more as a reference than as a support, it tends to force them into a quasi-pictorial frontality reinforced by a roughly rectangular configuration. Despite this, they are anything but pictures; they are more like ruminations on sculptural relief. Each "Bronze Screen" is dominated by a large, tapered convex sheet (see *Bronze Screen "Go To"* and *Bronze Screen "Return"*). While these are akin to picture surfaces, the very fact that they swell outwards towards the viewer transforms their "flatness" into something inherently sculptural. Despite their sometimes troublesome supports, the "Bronze Screens" stand upright in a new, non-totemic way.

The nature of art

Caro has become a prolific artist of great powers. In the 1960s he literally forged a new language for art and since that time has expanded its range enormously. Now, in the 1980s, his explorations have become even more varied, but they still remain narrowly focused. This explains his sculpture in different and seemingly intractable materials as well as his renewed interest in nature which, superficially, appears to be retrogressive. Waves, the conditions of architecture, and more recently figure studies, are all part of that interest. The explorations do not appear to be systematic, except in the sense that all of them push at the boundaries of the medium and all of them threaten to undermine it.

One aspect of these explorations began to assert itself in some small steel sculptures from the early 1980s which derive from drawings or photographs. While Caro had referred to reproductions of Picasso sculptures at Emma Lake, he now began to work in a variety of ways from contact with nature. *Billow* and *Breaker*, both from 1982, were inspired by wave formations Caro drew while on holiday in the Caribbean. While water may seem to be foreign to the nature of sculpture, waves, shaped by wind and tide, represent water in its most sculptural manifestation. Significantly, the relation between subject and sculpture was by no means simple and direct; Caro never enlarges small works without making radical changes (and seldom enlarges them at all). It was not so much that the "Wave" sculptures were derived from his holiday drawings as that the drawings were intermediate attempts to capture the nature of the subject, attempts to get at the roots of experience.

Pushing at the limits of the medium through the exploration of different materials was not new to Caro's art. In a sense it began when he first worked with steel in 1959 and was simply augmented during the 1970s with stainless steel, the "Flats", and then clay and bronze. To these were added unusual materials like silver and even paper, but of all these, lead and wood used together are the most unconventional. If the "Wave" series pitted Caro's experience of the world against the characteristics of steel, the lead and wood pieces from the same period detached from steel two of its most extreme characteristics, strength and malleability, and then attempted to reassemble them into a new whole.

Wood is lighter than steel and relatively strong, but does not lend itself to complex attachments. The fact that it calls for overlapping, surface-to-surface joins means that it has a limited repertoire of structural configurations. Lead, on the other hand, is soft and malleable but tremendously heavy. It is plastic like clay and, like clay, does not support itself well: it tends to hang and sag. Wood, for the most part, had to be used to support lead. While lead and wood together did

not produce as consistently good sculpture in Caro's hands as did steel or bronze, they nevertheless led to high accomplishments. Caro tended to use the materials best in relatively straightforward arrangements, which exploited the materials clearly and simply. In *Lay-By*, for example, bent, self-supportting lead flanges sit on top of a tilted wooden platform, while in *On the Double*, wide belts of lead wrap themselves over a tilted wooden frame.

Despite its forays into plasticity and even representation, a kind of quasi-architectural geometry lies at the heart of Caro's art. Because it flourishes in the sculptural format of the box, it is never far from architecture. Literal architecture enters Caro's sculpture in the *Child's Tower Room*, one of a series of involvements with the scale of architecture that have occupied Caro for a quarter of a century. The *Child's Tower Room* is closer to architecture than anything that preceded it. (In this it recalls room constructions by artists like Schwitters and Mondrian.) Taking upon itself the problem of interior and exterior apart from function, it attempts sculpture that can be experienced from inside as well as from without. The germ of that idea goes back a long way in Caro's art, to *After Summer* at the very least, and in a fundamental sense to the very beginning. It is a natural step from simply occupying the architectural box to constructing art which succeeds as both interior and exterior.

But is the art that results sculpture, or is it a kind of functionless architecture? In one sense the question is academic, so long as the result is good; in another it is of considerable importance, for it raises the danger of subsequent sculpture being undermined by a related art form that is inherently non-sculptural. Caro has stalked that margin for much of his career.

For the most part, Caro's steel pieces of the 1980s build upon the approach to volume inherent in the bronzes. Like many of the bronzes, they both occupy and contain space, only they do it with steel, which makes possible a greater variety of configurations than bronze. Cavities, especially rotund spherical ones, absorb space in many of the works. This is as true of the relatively small steel sculptures made at Triangle Workshop in New York State in 1982 and 1983 and in Edmonton, Canada, in 1984 as it is of the large works he made in London.

The yawning openings of these cavities were explored on a grand scale in a series of large sculptures with cavities from the mid 1980s, Caro's finest large sculptures since the "Flats". They contain enormous tub shapes jammed into structures of flat planes and posts. While these formidable works contain ideas suggested in sculptures of the late 1970s like *Nectarine*, the problem that undermined those sculptures has been resolved and transcended. Volumes are no longer provided by amorphous extrusions, but by large, tub-like containers framed by planes that shift away from strict frontality. The yawning cavities in these pieces give them a kind of resonance that suggests music, although a more complex and solemn music than was suggested in his early, more lyrical work. *Ocean, Double Variation, Odalisque, The Soldier's Tale*, and *Dream Garden*: these surpass the work of any sculptor alive and quite possibly of any from this century.

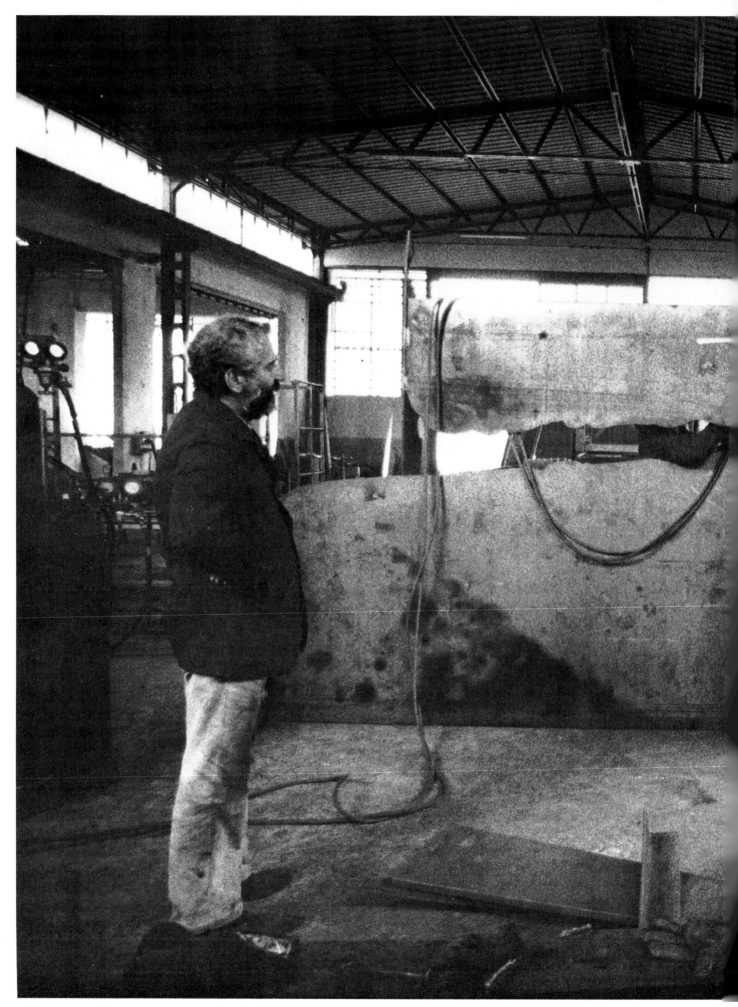

Caro in the Veduggio steel factory near Milan. 1974.

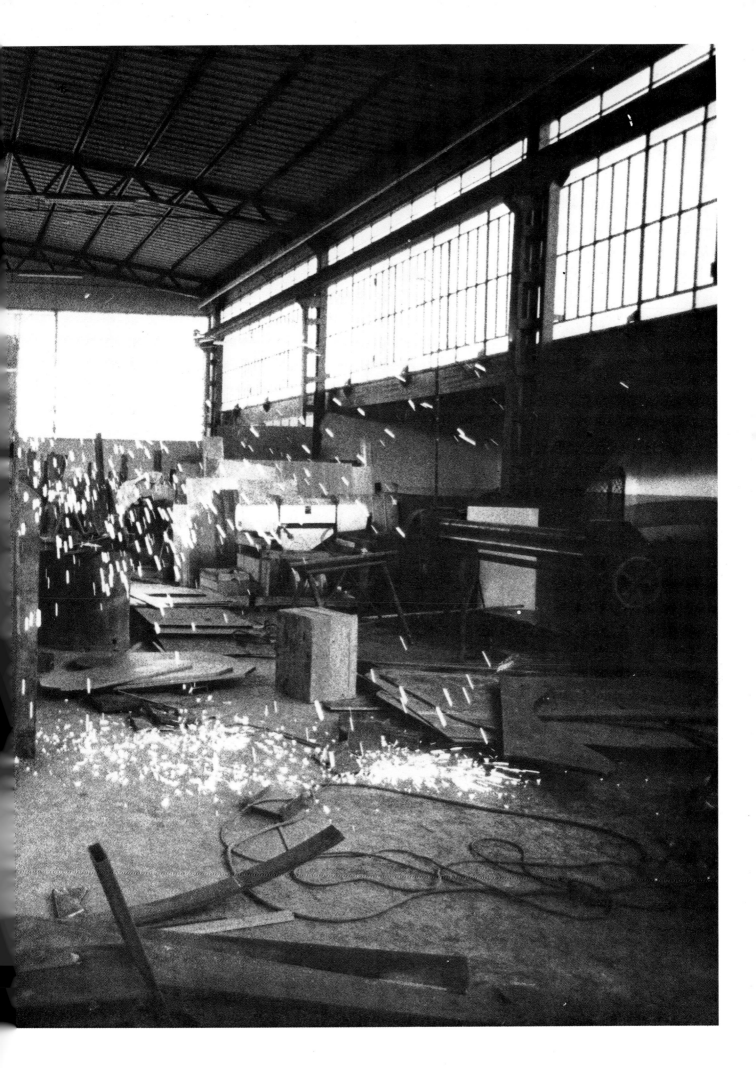

Biography

1924
Anthony Alfred Caro born on 8 March in New Malden, Surrey (England).

1937-1942
Is presented to the sculptor Charles Wheeler, the future President of the Royal Academy. Works in Wheeler's studio during the holidays.

1942-1944
Studies for a degree in engineering at Christ's College, Cambrige.

1948
Wins various prizes of the schools of the Royal Academy.

1949
On 17 December marries the painter Sheila Girling, who was a fellow student.

1951-1953
Moves to Much Hadham, Hertfordshire to work as part-time assistant to Henry Moore. Moore encourages him in the use of new materials, and gives him a broader understanding of 20th-century art and African art.

1953-1979
Starts to teach part-time at the St. Martin's School of Art with Frank Martin, head of Sculpture.

1953
Experiments using found objects as the starting point of his work and also working in clay.

1955
Interested in the work of Bacon, de Kooning and Dubuffet. First showing of his sculpture at the exhibition of *New Sculptors and Painter-sculptors* at the Institute of Contemporary Arts in London.

1956
First one-man show at the Galleria del Naviglio in Milan.

1957
One-man show at the Gimpel Fils Gallery in London.

1958
Pittsburgh Bicentennial Exhibition of Contemporary Painting and Sculpture. Carnegie Institute, Pittsburgh. 29th Venice Biennale in the Central Pavilion.

1959
The Tate Gallery buys *Woman Waking*. Meets the North American critic Clement Greenberg. Receives a scholarship to go to the United States. Meets David Smith, Adolph Gottlieb, Robert Motherwell, Helen Frankenthaler and Kenneth Noland.

1960
Abstract works which for the first time do without a base. Paints the works with industrial paints. Sets up soldering workshop in St Martin's School. Among his students in 1960 are Michael Bolus, Barry Flanagan, Philip King, Richard Long, Gilbert and George, Tim Scott, William Tucker and Bill Woodrow. *Sculpture in the Open Air* at Battersea Park.

1961
Itinerant exhibition of *Contemporary British Sculpture* organised by the Arts Council of Great Britain. Completes his first polychrome sculpture *Sculpture, Seven*.

1962
Jóvenes Escultores Ingleses exhibition at the Ateneo in Madrid.

1963
First one-man show of abstract sculptures in steel, at the Whitechapel Gallery, catalogue text written by Michael Fried. Moves temporarily to the United States to teach at Bennington College, Bennington, Vermont. On the advice of Noland, starts work on series (*Plans; Rain; Titan*).

1964
1954-1964: Painting and Sculpture of a Decade exhibition at the Tate Gallery, organised by the Calouste Gulbenkian Foundation. *Documenta III*, Kassel, Germany. First one-man show in the United States at the André Emmerich Gallery in New York.

1965
British Sculpture in the Sixties exhibition at the Tate Gallery, London, organized by the Contemporary Art Society.

1966
Primary Structures exhibition at the Jewish Museum in New York. The Museum of Modern Art of New York buys *Away*, later swapped for *Source. Five Young British Artists* exhibition at the British pavilion at the 33rd Biennale in Venice.

1967
American Sculpture in the Sixties exhibition at the Los Angeles County Museum.

1968
Noland, Louis and Caro exhibition at the Metropolitan Museum of Art, New York, organised by Henry Geldzahler. Receives a degree honoris causa from the University of East Anglia.

1969
Named Commander of the Order of the British Empire. First large retrospective exhibition at the Hayward Gallery, London. 10th Biennale of São Paulo, British Section.

1970
British Sculpture out of the Sixties exhibition at the Institute of Contemporary Arts, London. *British Painting and Sculpture, 1960-1970* exhibition at the National Gallery of Art in Washington.

1971
Works in different forms: large hovering diamond shapes, looping forms, stacked I-beams.

1972
One-man show at the André Emmerich Gallery in New York.

1973
One-man show at the André Emmerich Gallery in New York: *Table pieces*. The Museum of Modern Art, New York, acquires *Midday*.

1974
Works at the York Steel Company, in Toronto. Does thirty-seven large sculptures in heavy steel and using cranes.

1975
One-man retrospective show at the Museum of Modern Art, New York. Works with ceramic day in the workshop of Syracuse University, New York.

1976
Given the keys of the city of New York by Mayor Beame.

1977
One-man show at the André Emmerich Gallery in New York. One-man retrospective show of *Table Pieces* at the Tel Aviv Museum, Israel. Is invited to select works for the Exhibition *The Artist's Eye* at the National Gallery in London.

1978
Does his first ''Writing Pieces'', which are shown at the Knoedler Gallery in London.

1979
Made an Honorary Member of the American Academy of Arts and Letters.

1980
Julio González, David Smith, Anthony Caro, Tim Scott, Michael Steiner itinerant exhibition of sculptures in steel selected by Dominique Fourcade: Galerie de France. Makes bronze screens using cast volumetric pieces. Does his first sculptures in lead and wood.

1981
Becomes a member of the Council of the Royal College of Art, London, for two years. Elected an honorary fellow of Christ's College, Cambridge. Series of sculptures, most to be hung on walls, made of hand-made paper, at Tyler Graphics, Bedford, New York.

1982
Appointed to the Board of Governors of the Tate Gallery. One-man show *Bronze Screens and Table Sculptures* at the André Emmerich Gallery, New York.

1983
One-man show at the Waddington Galleries and the Knoedler Gallery in London.

1985
Exhibition at the Fundació Joan Miró in Barcelona.

Select Bibliography

1956
Theo Crosby: "Anthony Caro at Galleria del Naviglio, Milan". *Architectural Design*. March, p. 107.

Caro and Gravity, exhibition catalogue with foreword by Lawrence Alloway, Galleria del Naviglio, Milan.

1960
Michel Seuphor: *The Sculpture of This Century*, New York: Braziller, 1960, pp. 147, 150, 248. London: Zwemmer, 1961.

1963
Anthony Caro, exhibition catalogue with introduction by Michael Fried, Whitechapel Gallery, London.

1965
Clement Greenberg: "Anthony Caro". *Arts Yearbook 8: Contemporary Sculpture*, pp. 106-109. Reprinted as foreword to exhibition catalogue, Rijksmuseum Kröller-Müller, Otterlo, Holland, 1967, and in *Studio International*, September 1967, pp. 116-17.

Seven Sculptures, exhibition catalogue with introduction by Michael Benedikt, Institute of Contemporary Art, University of Pennsylvania.
The New Generation, exhibition catalogue with preface by Brian Robertson, Whitechapel Gallery, London.

1967
American Sculpture of the Sixties, exhibition catalogue with essay by Clement Greenberg entitled "Recentness of Sculpture", Los Angeles County Museum, pp. 24-26. Reprinted in *Art International*, April 1976, pp. 19-21.

1968
New British Painting and Sculpture, exhibition catalogue with introduction by Herbert Read and Bryan Robertson, University of California at Los Angeles. Reprinted in *Art International*, February 1968, pp. 26-30.

1969
Charles Harrison: "London Commentary: Anthony Caro's Retrospective Exhibition at the Hayward Gallery". *Studio International*, March, pp. 130-31.

Anthony Caro 1954-1968, catalogue for the retrospective exhibition, with introduction by Michael Fried, Hayward Gallery, London.
X Bienal de São Paulo, exhibition catalogue with text by Charles Harrison (in Portuguese and English), pp. 80-89.

1974
Anthony Caro, Table Top Sculptures 1973-1974, exhibition catalogue with introduction by John Jacob, Kenwood House, London.

Sculpture in Steel, exhibition catalogue with introduction by Karen Wilkin, Edmonton Art Gallery, Alberta, Canada.

1975
Barry Martin: "On the Occasion of Anthony Caro's Retrospective Exhibition", *Studio International*, May-June, pp. 233-35.

William Rubin: *Anthony Caro*, New York: Museum of Modern Art, and London: Thames & Hudson, 1975. Catalogue for Retrospective Exhibition.

1976
English Art Today 1960-1976, exhibition catalogue with text by Noël Channon, Comune di Milano; Palazzo Reale, Milan, February-March, pp. 234-39.

1978
Fifteen Sculptors in Steel Around Bennington, 1963-1978, exhibition catalogue with text by Andrew Hudson, North Bennington, Vermont: Park McCullough House Association.

1980
Anthony Caro: Bronze Sculpture, exhibition catalogue, Acquavella Contemporary Art, New York.

Anthony Caro: The York Sculptures, catalogue with text by Christopher Andreae, Museum of Fine Arts, Boston.

González/Smith/Caro/Scott/Steiner, exhibition catalogue with text by Dominique Fourcade, Galerie de France, Paris.

L'Amérique aux Indépendants, exhibition catalogue with text by Lois de Menil, Société des Artistes, Grand Palais, Paris, pp. 37, 62, 65.
Sculpture at Storm King, New York: Abbeville Press Inc. Preface by J. Carter Brown, photography by David Finn, text by H. Peter Stern and David Collens, pp. 69, 102.

1981
Dieter Blume: *Anthony Caro*, catalogue raisonné in four volumes: "Table and Related Sculptures, 1966-1978", "Table and Related Sculptures, 1979-1980, Miscellaneous Sculptures 1974-1980, Bronze Sculptures 1976-1980", "Steel Sculptures 1960-1980" and "Student Work 1942-1953, Figurative Sculptures 1954-1959". Published by Galerie Wentzel, Cologne, Germany.

Anthony Caro: Recent Bronzes 1976-1981, exhibition catalogue with text by John Jacob, at the Iveagh Bequest, Kenwood; published by the Greater London Council.

Anthony Caro: Sculptures, catalogue with text by Karen Wilkin, Storm King Art Center, Mountainville, New York.

Late Twentieth Century Art, exhibition catalogue with text by Frederick Brandt and Susan Butler: Sidney and Frances Lewis Foundation, Richmond, Virginia, pp. 12-13.

1982
Anthony Caro: Bronze Screens, exhibition catalogue, André Emmerich Gallery, New York.

Anthony Caro: Recent Bronze Sculpture, exhibition catalogue with essay by Karen Wilkin, Gallery One, Toronto, Ontario.

1983
Anthony Caro: Recent sculptures, steel and bronze, exhibition catalogue with introduction by Christopher Andreae, Knoedler Gallery and Waddington Galleries, London.

1984
Anthony Caro 1982-1984 Four Phases, exhibition catalogue, André Emmerich Gallery and Acquavella Galleries, New York, May 24th - June 29th.

Anthony Caro Sculpture 1969-1984, exhibition catalogue with foreword by Joanna Drew and Catherine Lampert and introduction by Tim Hilton, Serpentine Gallery, London.

Six in Bronze, exhibition catalogue. Williams College Museum of Art, Williamstown, Massachusetts.

1986
Dieter Blume: *Anthony Caro*, fifth volume of the catalogue raisonné, (see 1981).

1 *Midday*. 1960.
Steel painted yellow,
94½'' × 38'' × 144'' / 240 × 96.5 × 366 cm.

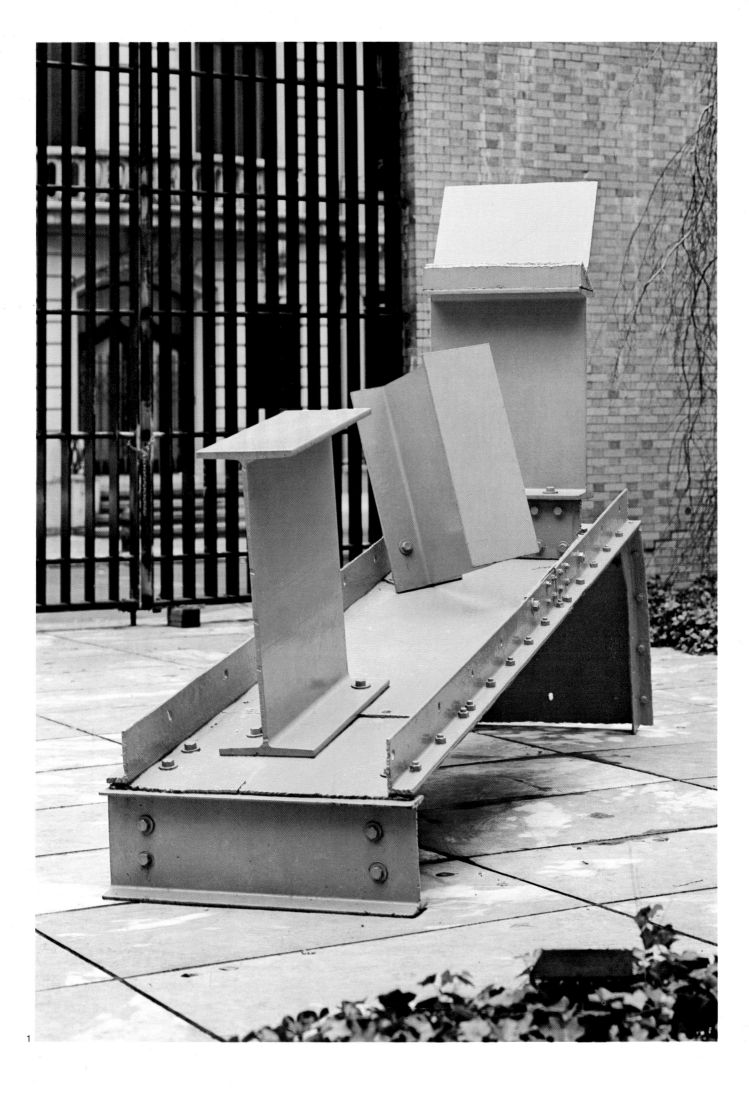

2 *Twenty-Four Hours*. 1960.
Steel painted dark brown and black,
54½'' × 88'' × 35'' / 138.5 × 223.5 × 89 cm.

3 *The Horse*. 1961.
Steel painted dark brown,
80'' × 38'' × 168'' / 203.5 × 96.5 × 427 cm.

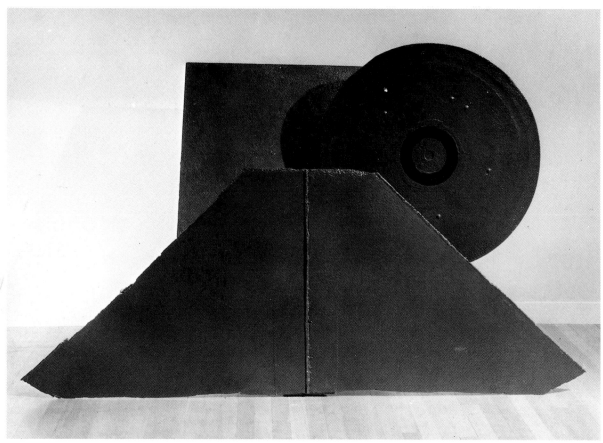

2

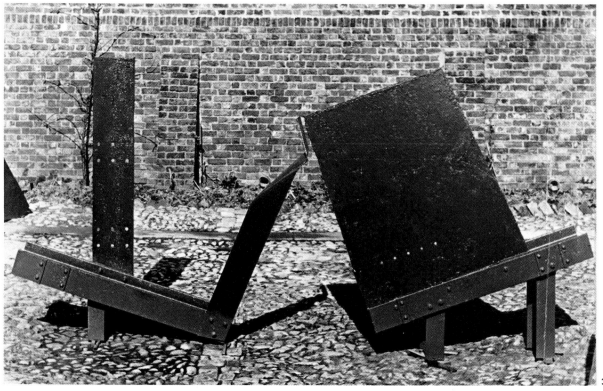

3

4 *Sculpture Seven*. 1961.
Steel painted green, blue and brown,
70'' × 211½'' × 41½'' / 178 × 537 × 105.5 cm.

5 *Sculpture Three*. 1961.
Steel painted green,
117'' × 173'' × 55'' / 297 × 439.5 × 140 cm.

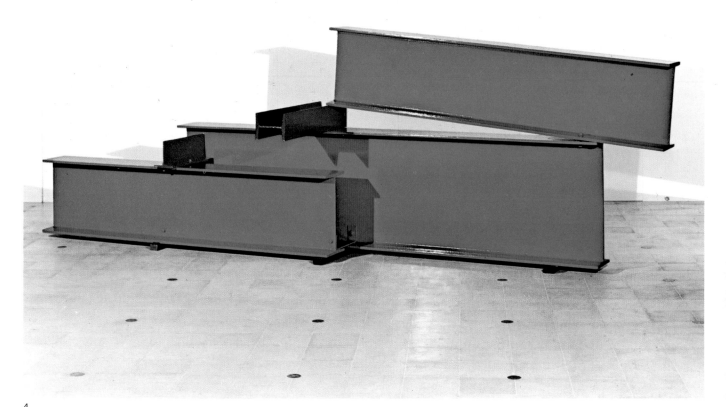

4

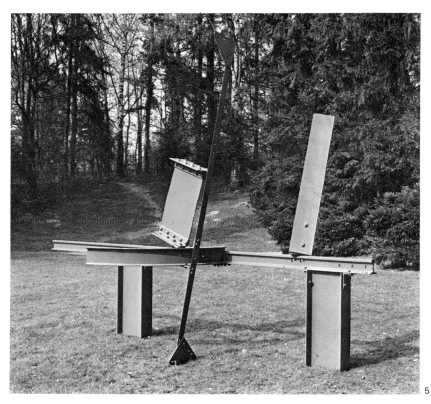

5

6 *Hop Scotch*. 1962.
Aluminium,
98½'' × 84'' × 187'' / 250 × 213.5 × 475 cm.

7 *Sculpture Three*. 1962.
Steel painted red,
108'' × 181'' × 67'' / 274.5 × 460 × 170.5 cm.

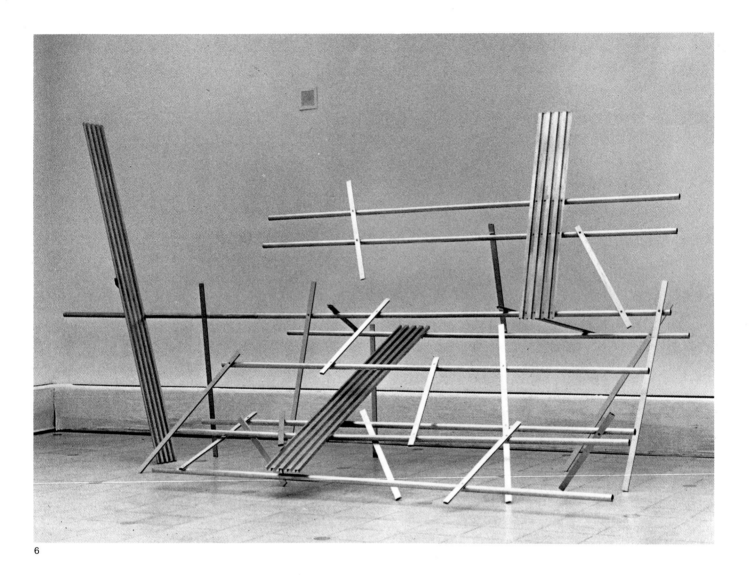

6

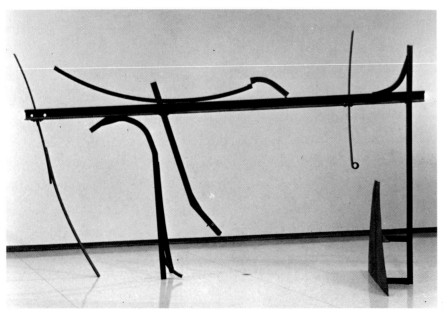

7

8 *Early One Morning*. 1962.
Steel and aluminium, painted red,
114'' × 244'' × 131'' / 290 × 620 × 333 cm.

9 *Lock*. 1962.
Steel painted blue,
34½'' × 211'' × 120'' / 88 × 536 × 305 cm.

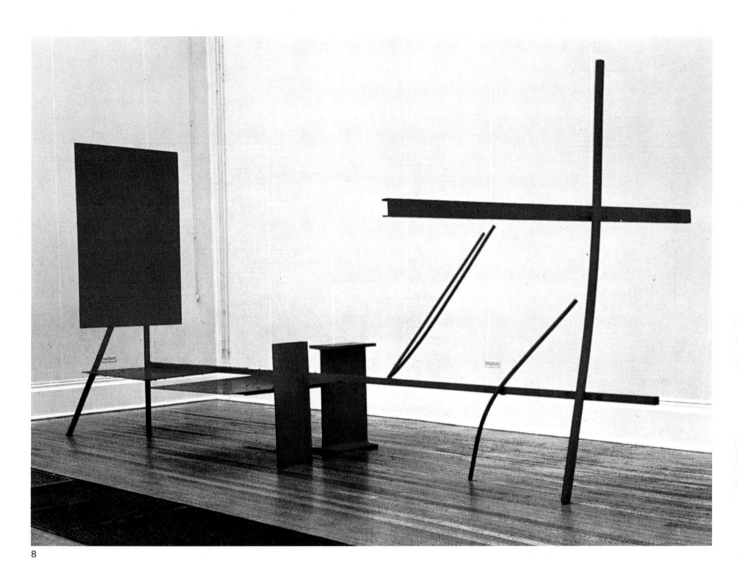

8

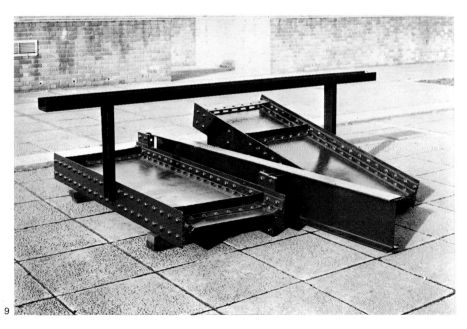

9

10 *Sculpture Two*. 1962.
Steel painted green,
82'' × 142'' × 102'' / 208.5 × 361 × 259 cm.

11 *Month of May*. 1963.
Steel and aluminium, painted magenta, orange and green,
110'' × 120'' × 141'' / 279.5 × 305 × 358.5 cm.

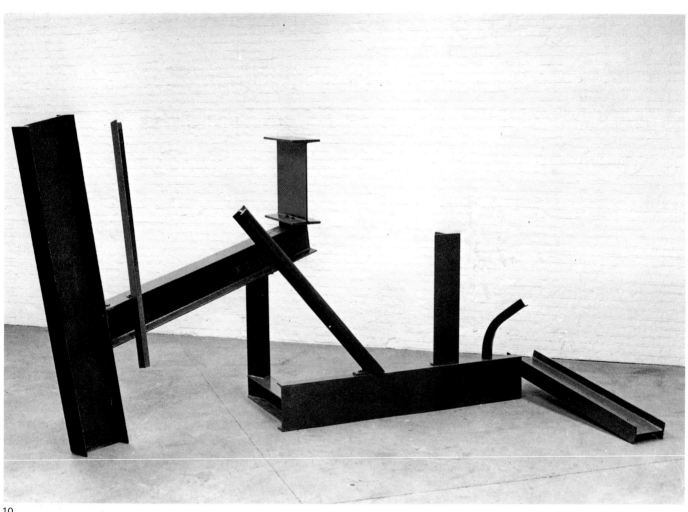

10

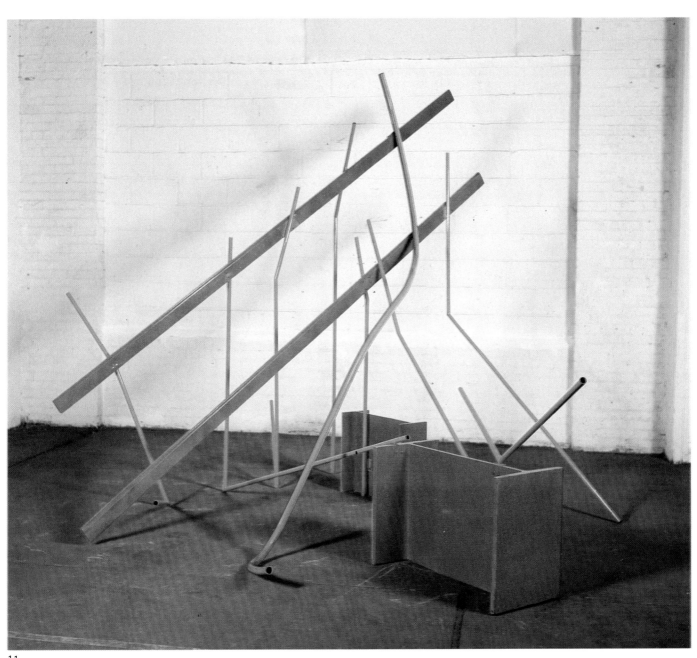

11

12 *Bennington*. 1964.
Steel painted primer red,
40″ × 166″ × 133½″ / 102 × 422 × 339 cm.

13 *Pulse*. 1964.
Steel painted pink and green,
21½″ × 56″ × 111″ / 54.5 × 142.5 × 282 cm.

14 *Flats*. 1964.
Steel painted red and blue,
37½″ × 91″ × 120″ / 95.5 × 231.5 × 305 cm.

15 *Titan*. 1964.
Steel painted blue,
41½″ × 144″ × 114″ / 105.5 × 366 × 290 cm.

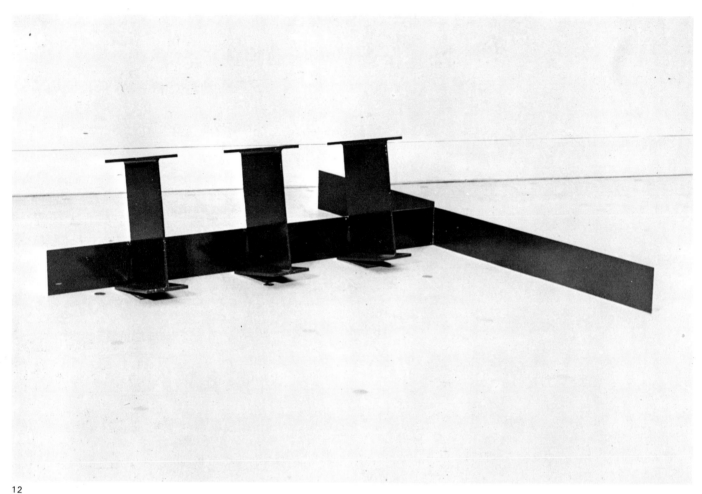

12

13
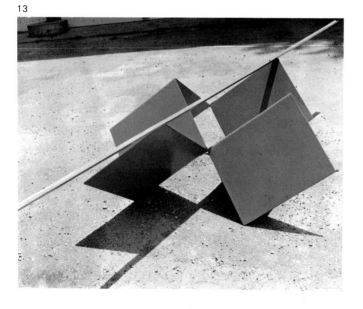

14

1

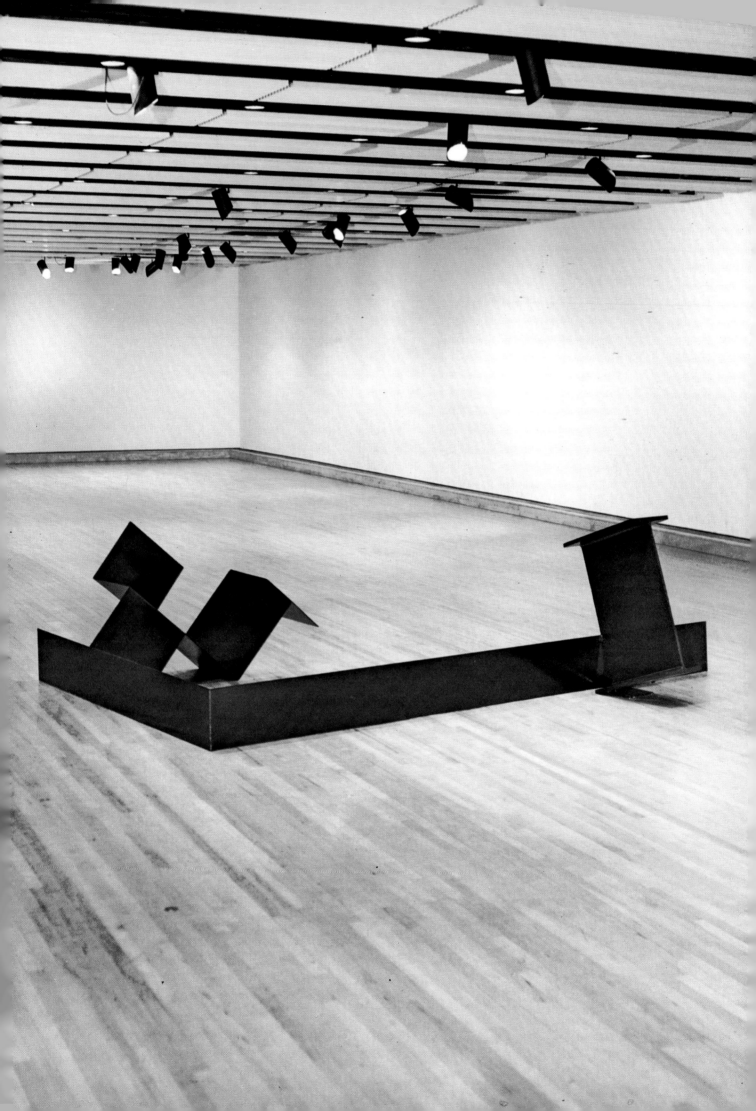

16 *Sleepwalk*. 1965.
Steel painted orange,
110'' × 100'' × 288'' / 279.5 × 254 × 731.5 cm.

17 *Strip*. 1965.
Steel and aluminium, painted red,
7'' × 3'' × 78¾'' / 18 × 7.5 × 200 cm.

18 *Sight*. 1965/69.
Steel painted blue,
112½'' × 66'' × 3'' / 286 × 168 × 7.5 cm.

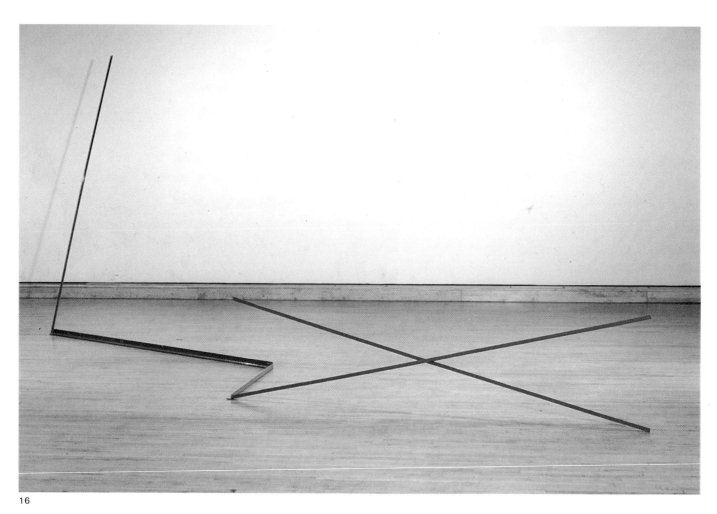

16

17

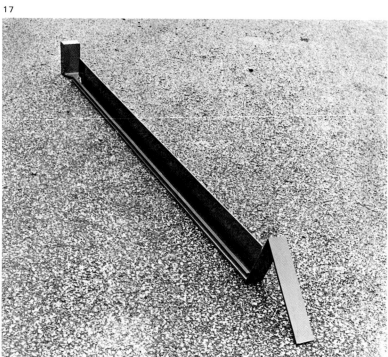

18

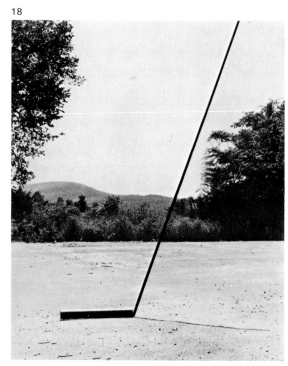

19 *Wide*. 1964.
Steel and aluminium, painted burgundy,
58¾'' × 60'' × 160'' / 149.5 × 152.5 × 406.5 cm.

20 *Green Sleeper*. 1965.
Steel painted green,
12'' × 58'' × 43'' / 30.5 × 147.5 × 109 cm.

21 *Smoulder*. 1965.
Steel painted purple,
42'' × 183'' × 33'' / 106.5 × 465 × 84 cm.

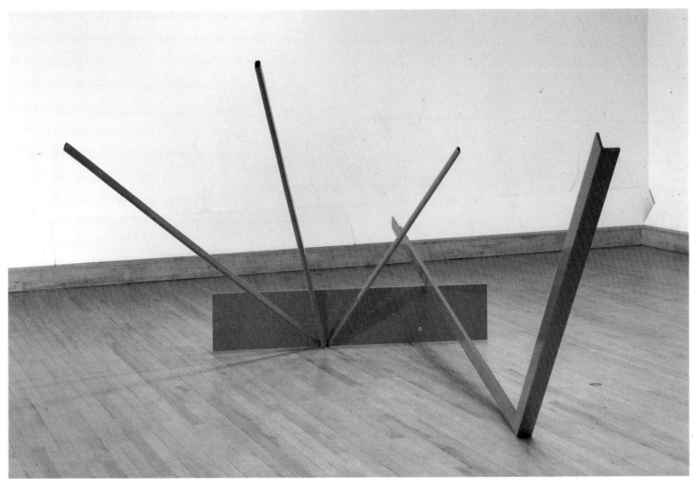

19

20

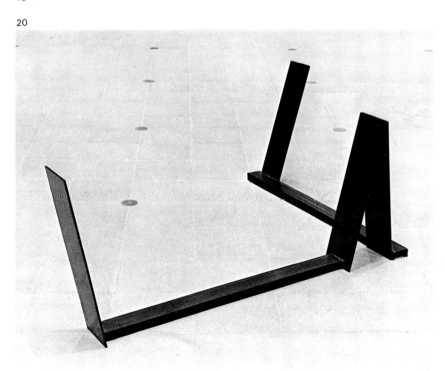

21

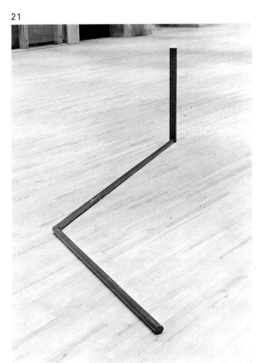

22　*Shaftsbury*. 1965.
　　Steel painted purple,
　　27'' × 127'' × 108'' / 68.5 × 323 × 274.5 cm.

23　*Span*. 1966.
　　Steel painted burgundy,
　　77½'' × 184'' × 132'' / 197 × 468 × 335.5 cm.

24　*Deep Body Blue*. 1967.
　　Steel painted stark blue,
　　58½'' × 101'' × 124'' / 149 × 256.5 × 315 cm.

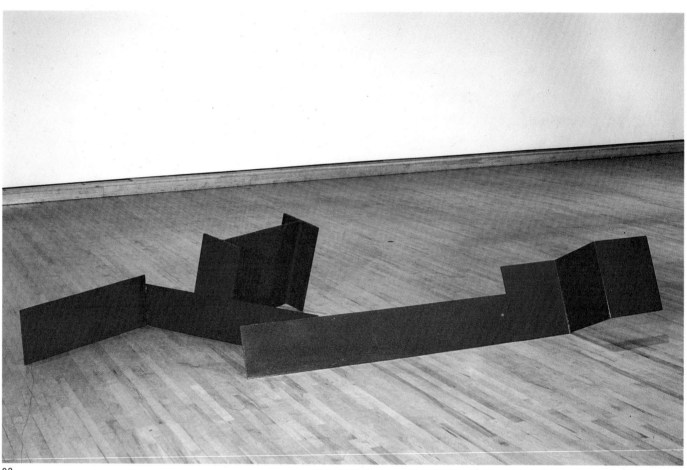

22

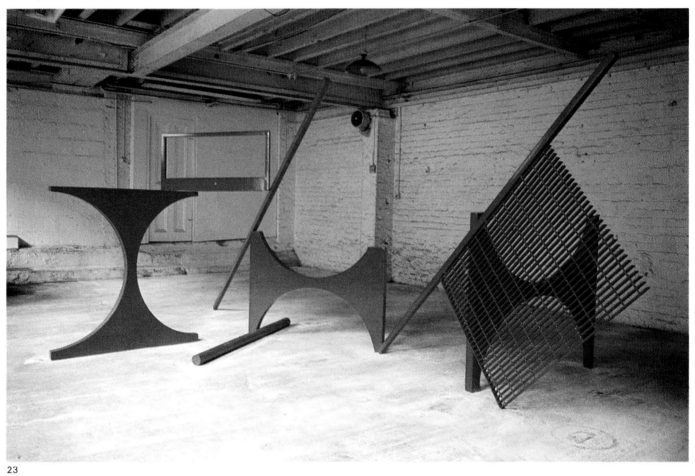

23

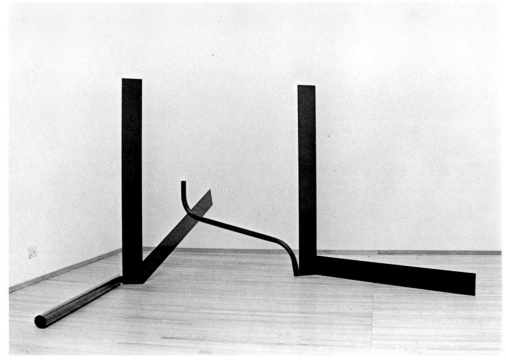

24

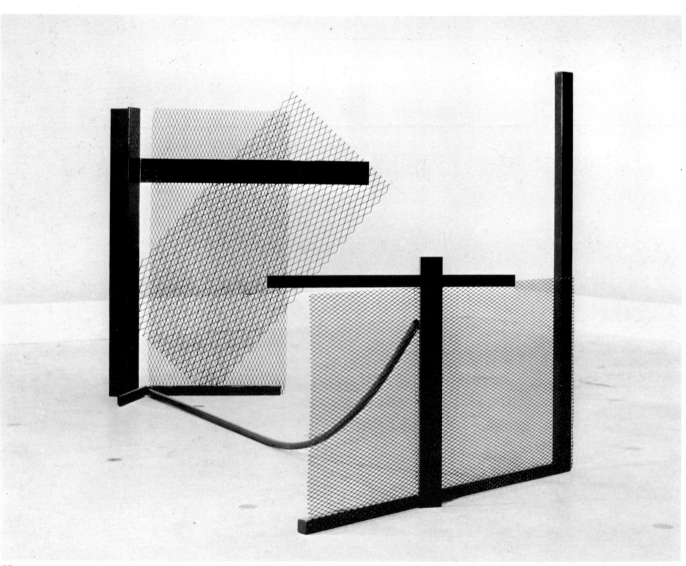

25

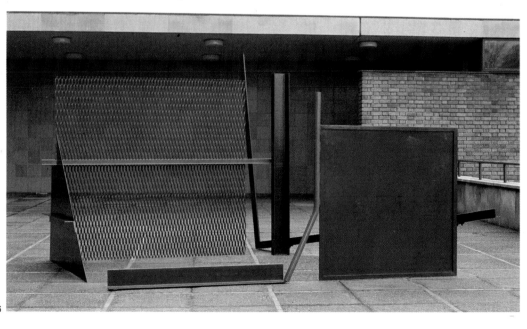

26

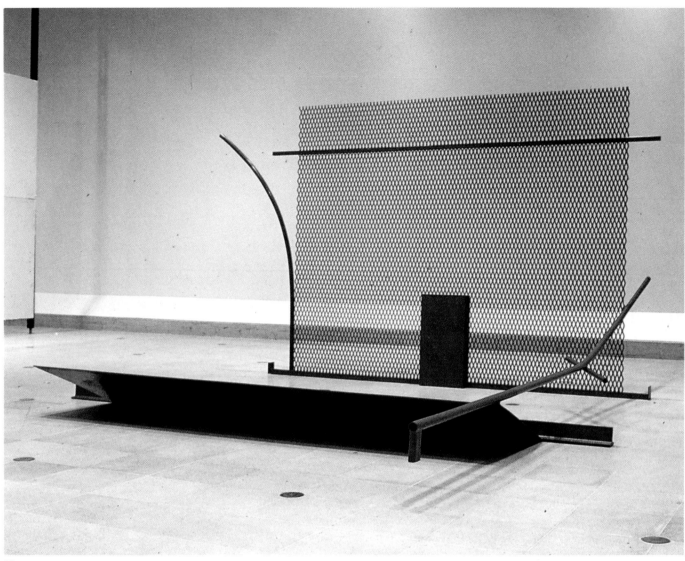

27

25 *Carriage*. 1966.
Steel painted blue,
77'' × 80'' × 156'' / 195.5 × 203.5 × 396.5 cm.

26 *The Window*. 1966/67.
Steel painted green and olive green,
84¾'' × 126¼'' × 153½'' / 215 × 320.5 × 390 cm.

27 *Source*. 1967.
Steel and aluminium, painted green,
73'' × 120'' × 141'' / 185.5 × 305 × 358 cm.

28-29 *Prairie*. 1967.
 Steel painted matt yellow,
 38″ × 229″ × 126″ / 96.5 × 582 × 320 cm.

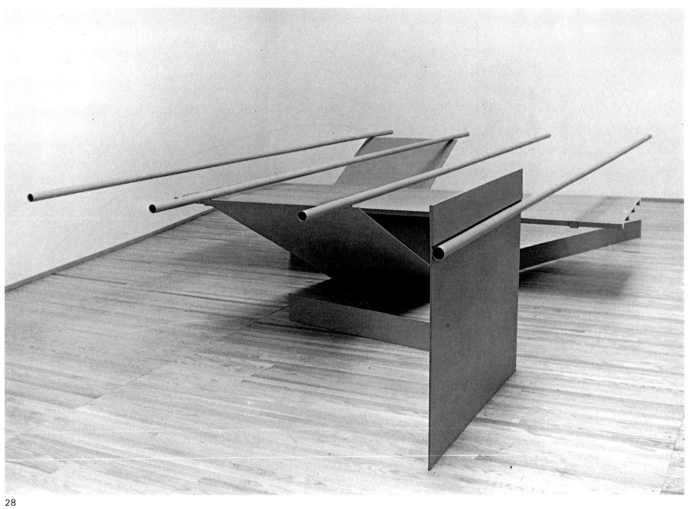

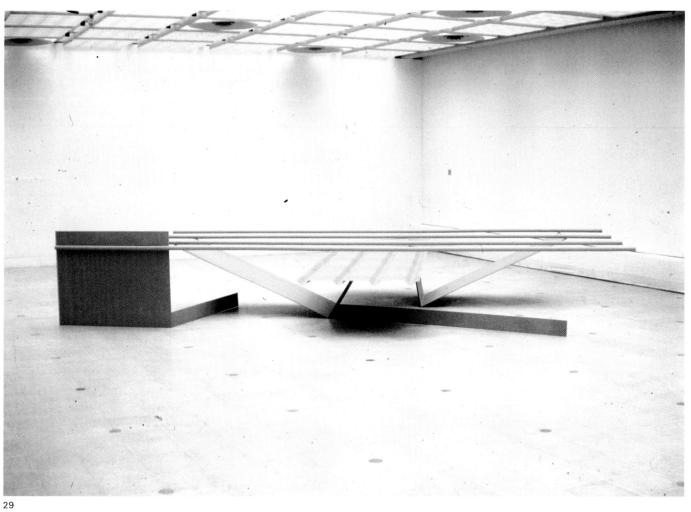

29

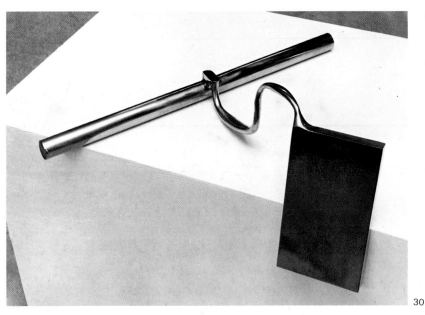

30

30 *Table Piece XVIII*. 1967.
Steel polished and lacquered,
10'' × 21'' × 20'' / 25.4 × 53.3 × 50.8 cm.

31 *Table Piece XIV*. 1966.
Steel polished,
10'' × 24'' × 19½'' / 25.4 × 61 × 49.5 cm.

32 *Table Piece XXXVII*. 1967.
Steel painted grey,
20½'' × 21'' × 14¾'' / 52.1 × 53.3 × 37.5 cm.

33 *Table Piece XXII*. 1967.
Steel sprayed jewelescent green,
10'' × 31½'' × 27'' / 25.4 × 80 × 68.6 cm.

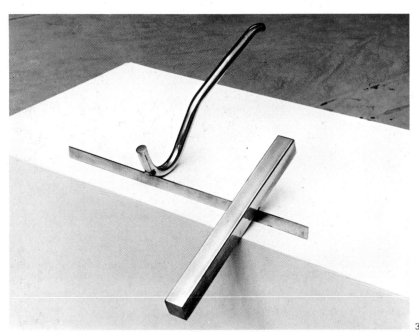

31

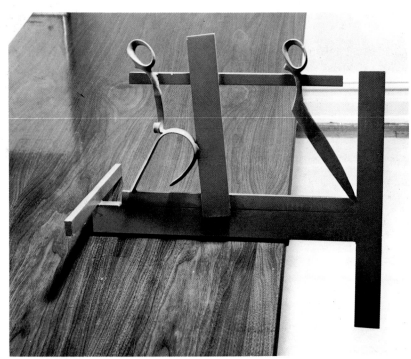

32

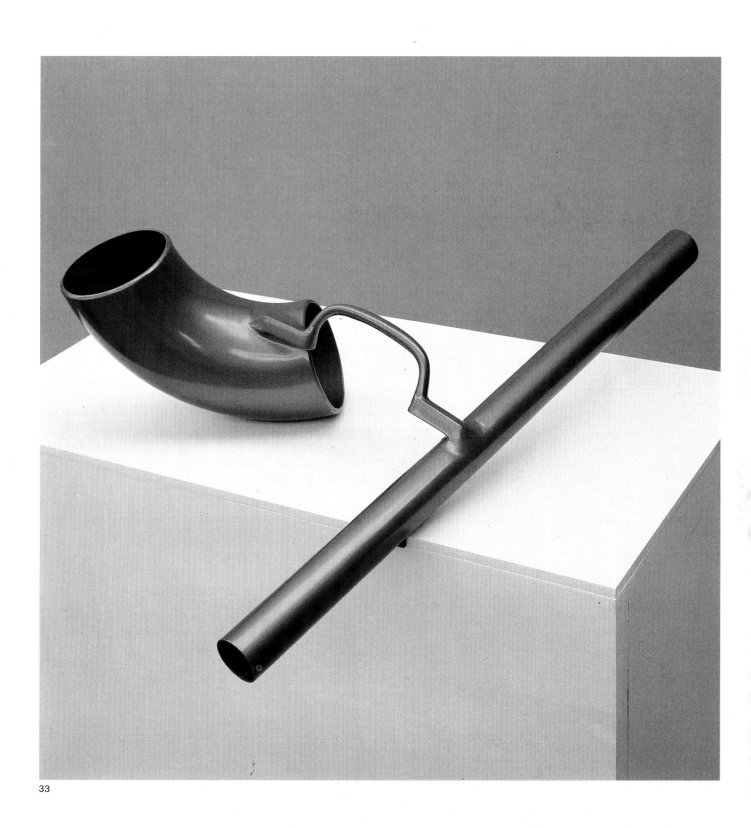

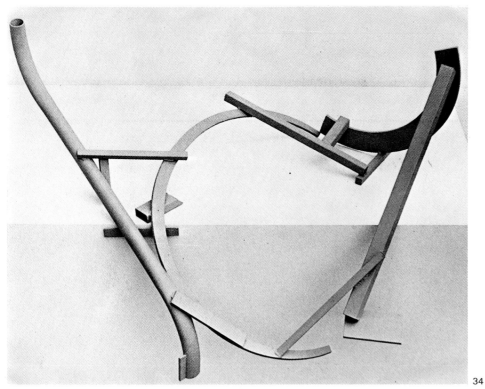

34

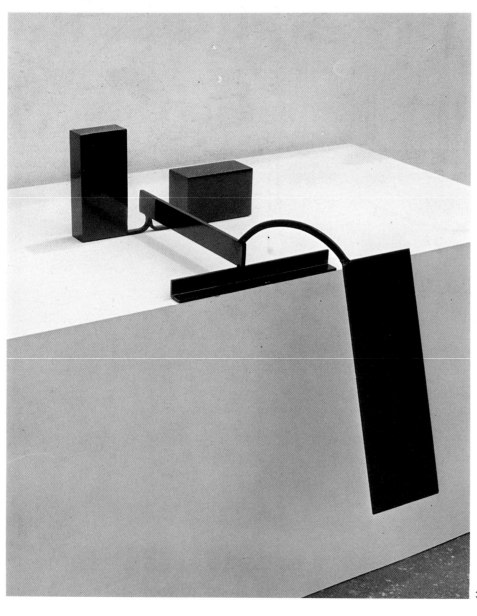

35

34 *Table Piece LXIV (The Clock)*. 1968.
Steel painted zinc chromate primer,
30″ × 51″ × 32″ / 76.2 × 129.5 × 81.3 cm.

35 *Table Piece XLII*. 1967.
Polished steel sprayed green,
23½″ × 15½″ × 29″ / 59.7 × 39.4 × 73.7 cm.

36 *Trefoil*. 1968.
Steel painted matt yellow,
83″ × 100″ × 65″ / 211 × 254 × 165 cm.

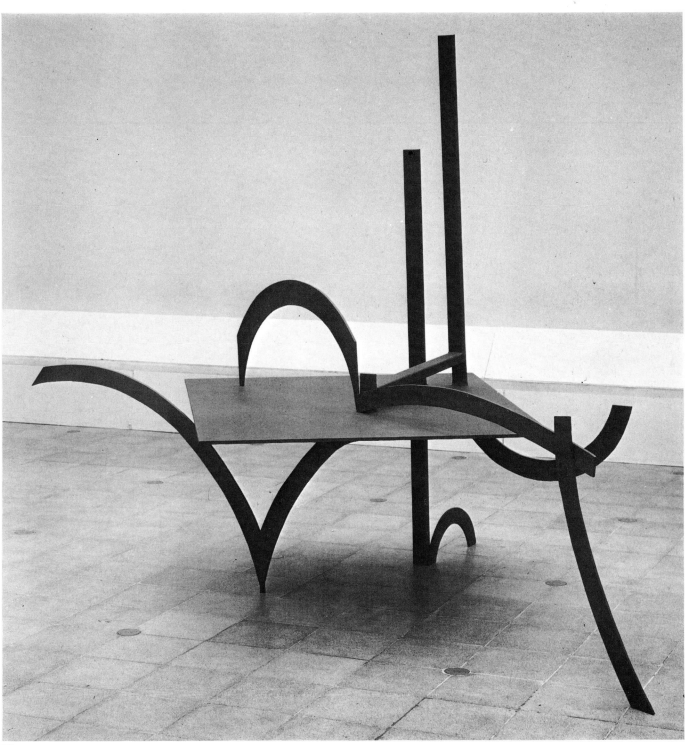

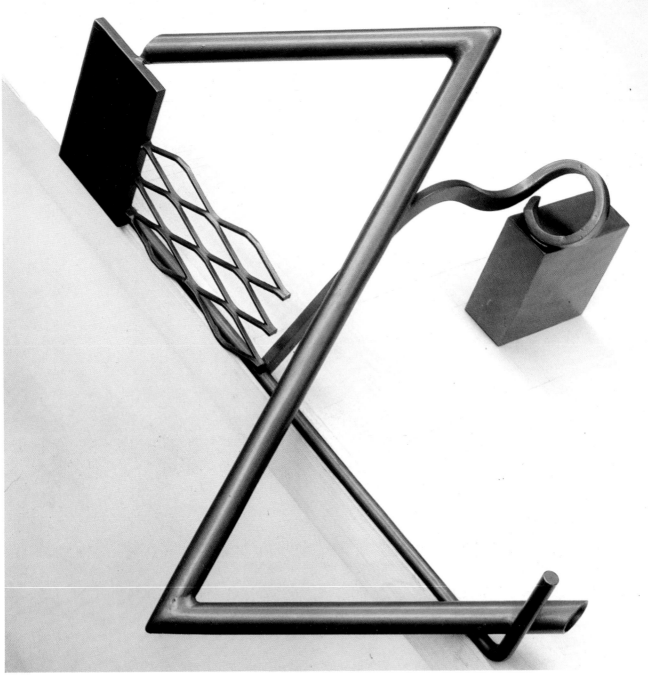

37

37 *Table Piece LIX*. 1968.
Steel sprayed silver grey,
11½'' × 17'' × 19'' / 29.2 × 43.2 × 48.3 cm.

38 *Table Piece LXXXVIII (Deluge)*. 1969.
Steel painted zinc chromate primer,
40'' × 63'' × 38'' / 101.6 × 160 × 96.5 cm.

39 *Table Piece XLIX*. 1968.
Steel painted green,
20½'' × 32'' × 25'' / 52.1 × 81.3 × 63.5 cm.

40 *Table Piece LVIII*. 1968.
Steel sprayed cherry,
20¼'' × 32'' × 31'' / 50.6 × 80 × 77.5 cm.

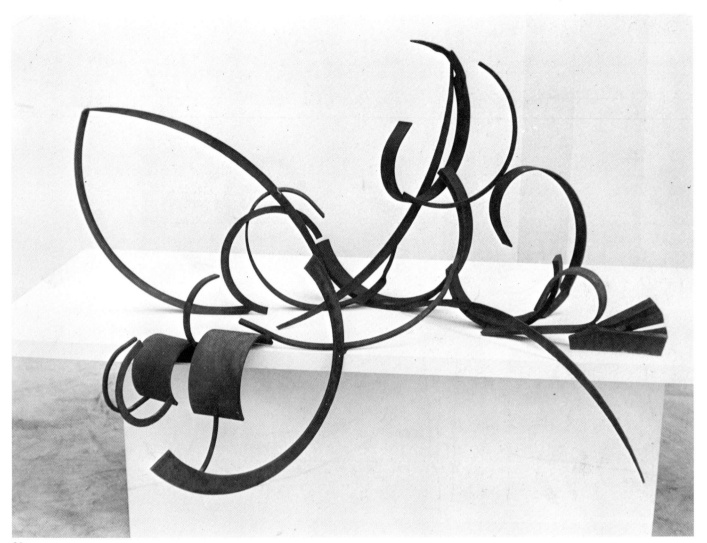

38

39
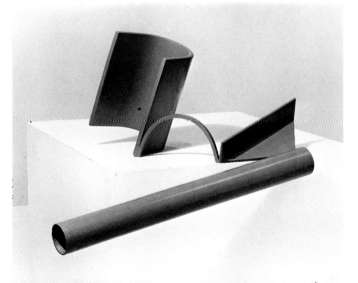

40

41 *After Summer*. 1968.
Steel painted grey,
62'' × 236'' × 288'' / 157.5 × 599.5 × 731.5 cm.

42 *Argentine*. 1968.
Steel painted purple,
59'' × 140'' × 124'' / 150 × 355.5 × 315 cm.

43 *Orangerie*. 1969.
Steel painted red,
88½'' × 64'' × 91'' / 225 × 162.5 × 231 cm.

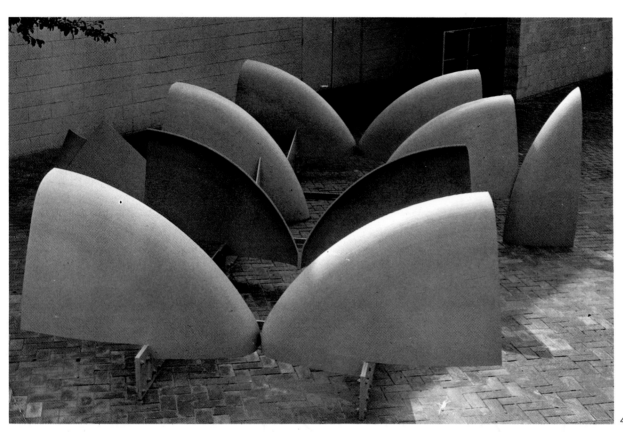

41

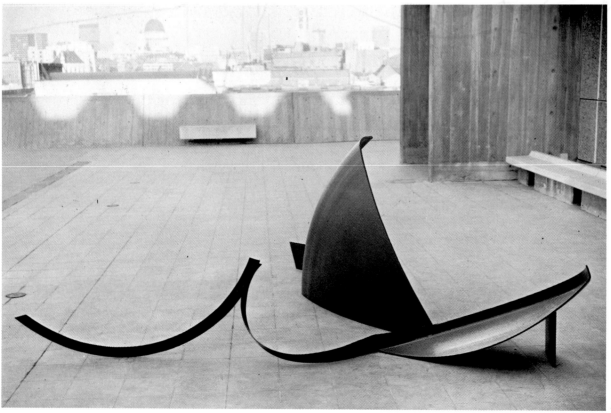

42

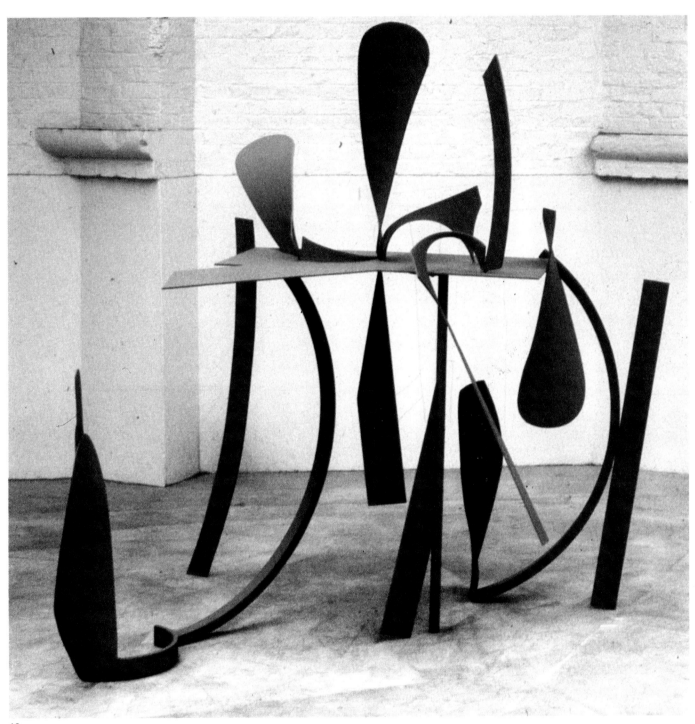

43

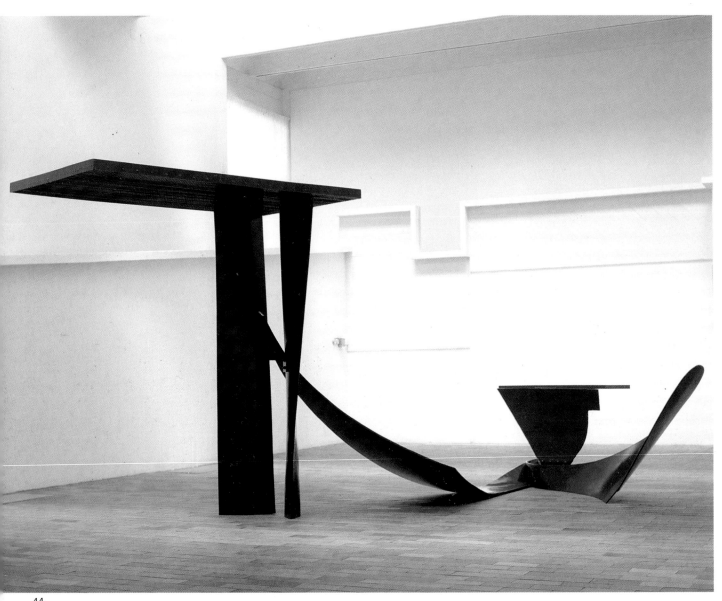

44

44 *Deep North*. 1969/70.
Steel and aluminium, painted green,
96″ × 228″ × 114″ / 244 × 579 × 289.5 cm.

45 *Garland*. 1970.
Steel painted green and red,
55″ × 169″ × 148″ / 140 × 429.5 × 376 cm.

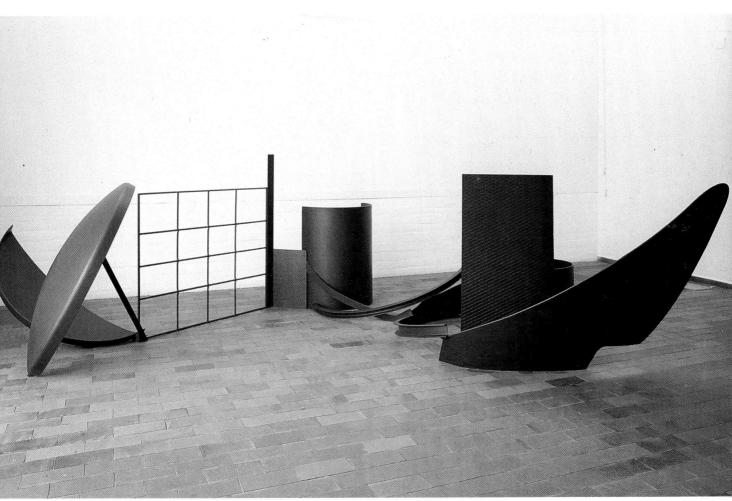

45

46 *Table Piece XCVII*. 1970.
Steel painted tan,
25″ × 53″ × 44″ / 63.5 × 134.6 × 111.8 cm.

47 *Table Piece XCI*. 1969/70.
Steel painted brown,
20″ × 62″ × 41″ / 50.8 × 157.5 × 104.1 cm.

48 *Tempus*. 1970.
Steel painted green,
45″ × 46½″ × 47″ / 114.5 × 118 × 119.5 cm.

49 *Wending Back*. 1969.
Steel painted grey,
43″ × 126″ × 102″ / 109 × 320 × 259 cm.

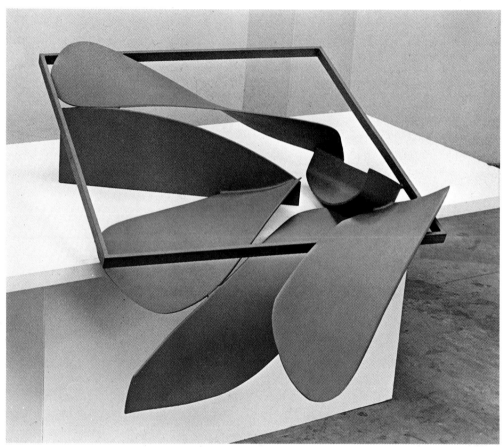

46

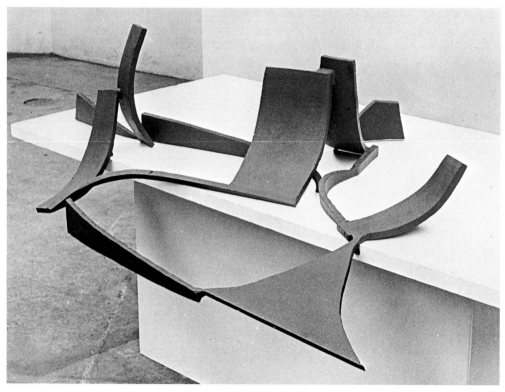

47

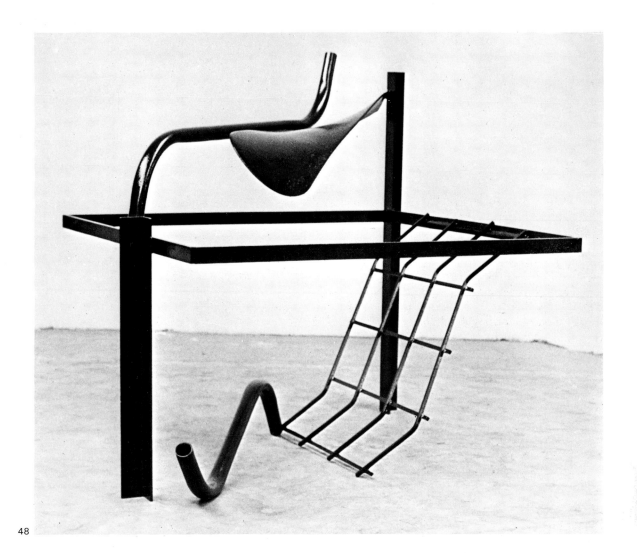

48

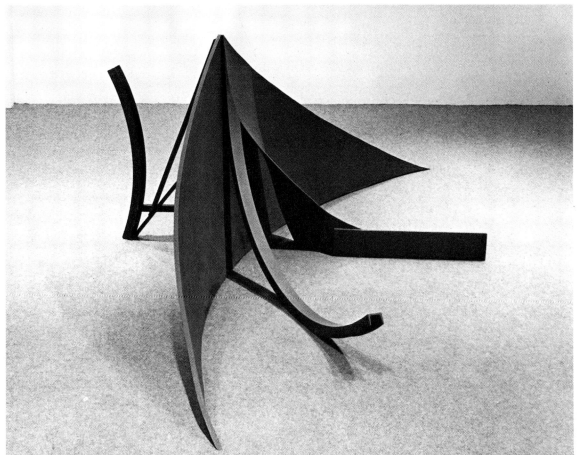

49

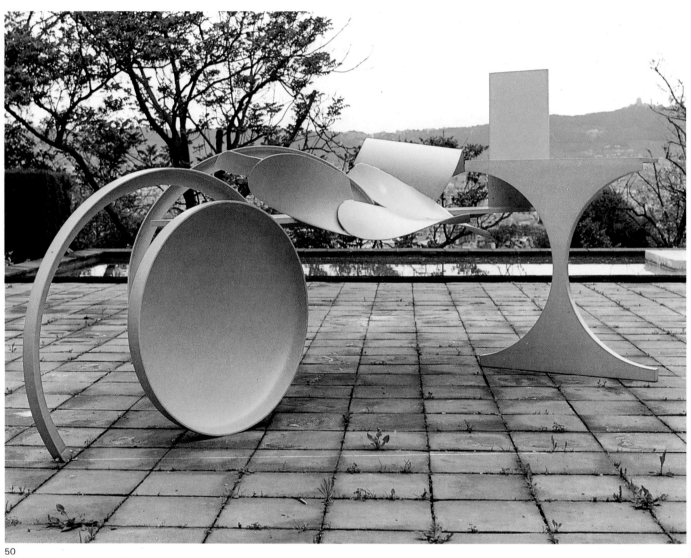

50

50 *Sun Feast*. 1969/70.
Steel painted yellow,
71½'' × 164'' × 86'' / 181.5 × 416.5 × 218.5 cm.

51 *The Bull*. 1970.
Steel rusted,
32'' × 119'' × 57'' / 81.5 × 302.5 × 145 cm.

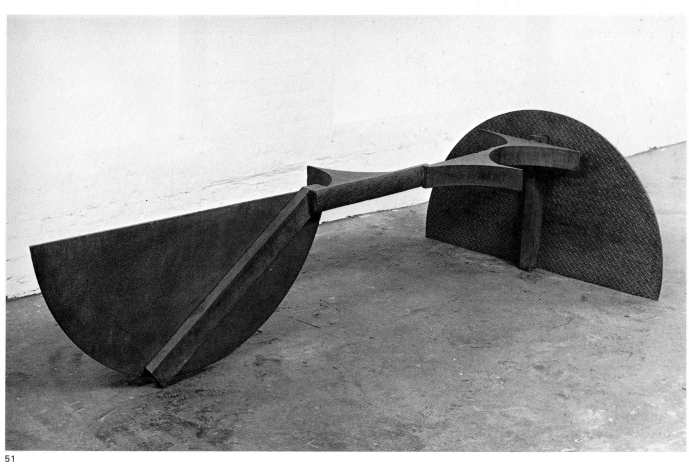

51

52 *Ordnance*. 1971.
Steel rusted and varnished,
51'' × 76'' × 143'' / 129.5 × 193 × 363 cm.

53 *Picket*. 1970.
Steel rusted,
39'' × 65½'' × 34'' / 99 × 166.5 × 86.5 cm.

54 *Side Step*. 1971.
Steel painted brown,
51'' × 115'' × 58'' / 129.5 × 292 × 147.5 cm.

55 *Canal*. 1971.
Steel rusted,
41'' × 72½'' × 65'' / 104 × 184 × 165 cm.

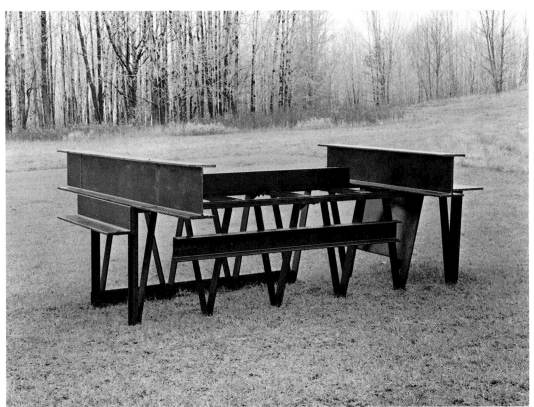

52

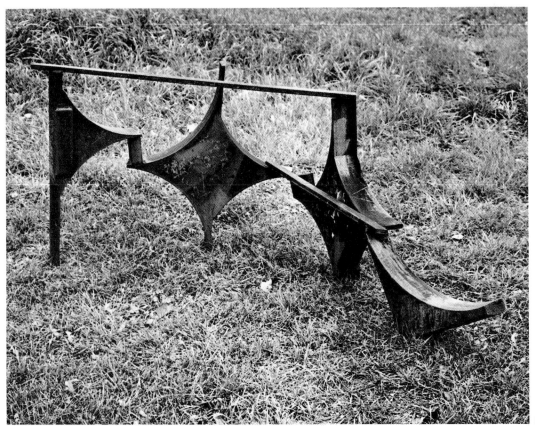

53

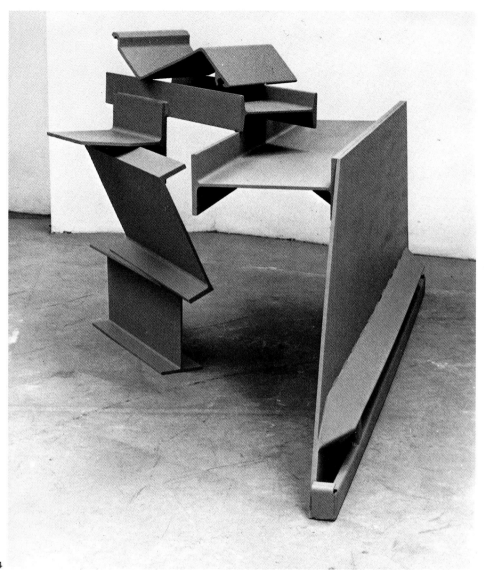

54

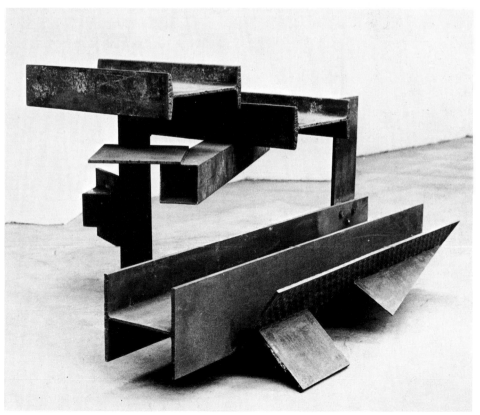

55

56 *Cool Deck*. 1970/71.
Stainless steel,
22″ × 64″ × 124″ / 56 × 162.5 × 315 cm.

57 *Box Piece F*. 1972.
Stainless steel,
20½″ × 73″ × 23″ / 52.1 × 185.4 × 58.4 cm.

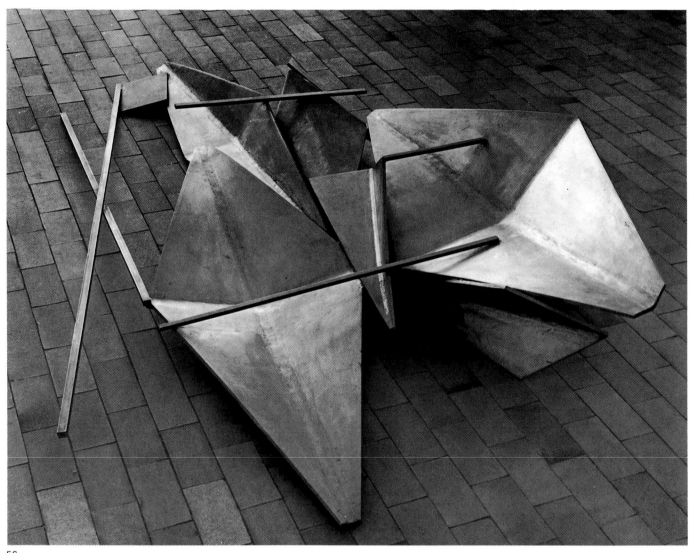

56

57

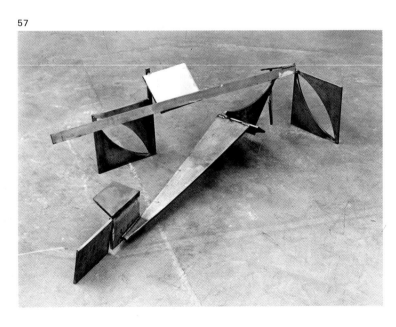

58 *Up Front*. 1971.
Steel painted red,
69'' × 110'' × 46½'' / 175.5 × 279.5 × 118 cm.

59 *Crown*. 1970/71.
Steel painted red,
42½'' × 82'' × 32'' / 108 × 208.5 × 81.5 cm.

60 *Cherry Fair*. 1971.
Steel painted brown,
36'' × 87'' × 74'' / 91.5 × 221 × 188 cm.

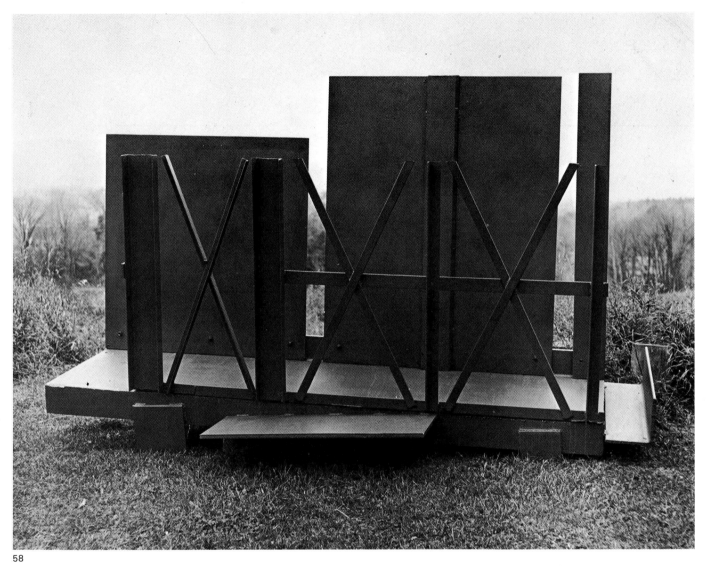

58

59

60

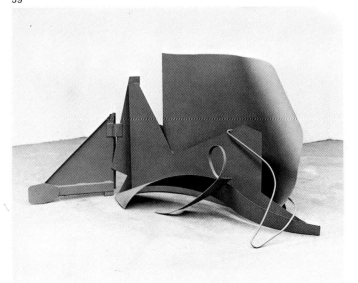

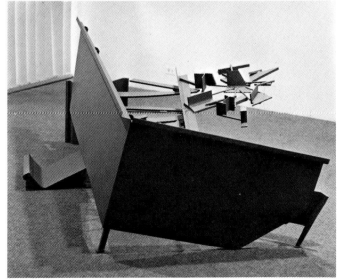

61 *Straight On*. 1972.
Steel rusted with red paint rubbed in,
79'' × 68'' × 52'' / 201 × 173 × 132 cm.

62 *Straight Up*. 1972.
Steel rusted,
56'' × 43'' × 68'' / 142 × 109 × 173 cm.

63 *Straight Cut*. 1972.
Steel rusted and painted silver,
52'' × 62'' × 51'' / 132 × 157.5 × 129.5 cm.

64 *Straight Measure*. 1972.
Steel rusted and painted,
46½'' × 75'' × 59'' / 118 × 190.5 × 150 cm.

65 *Veduggio Sun*. 1972/73.
Steel rusted and varnished,
99'' × 120'' × 54'' / 251.5 × 305 × 137 cm.

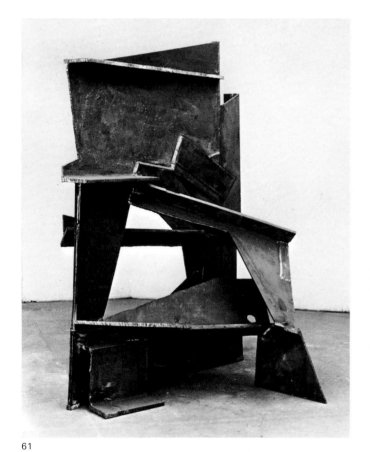

61

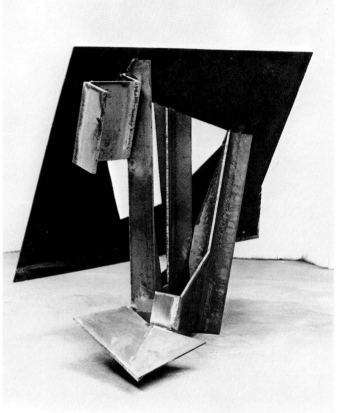

62

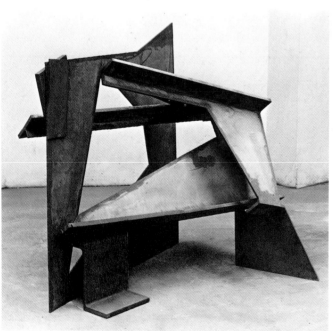

63

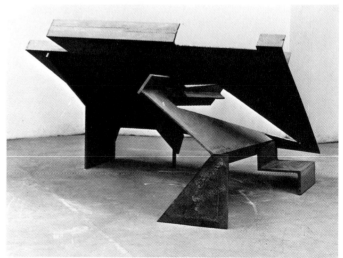

64

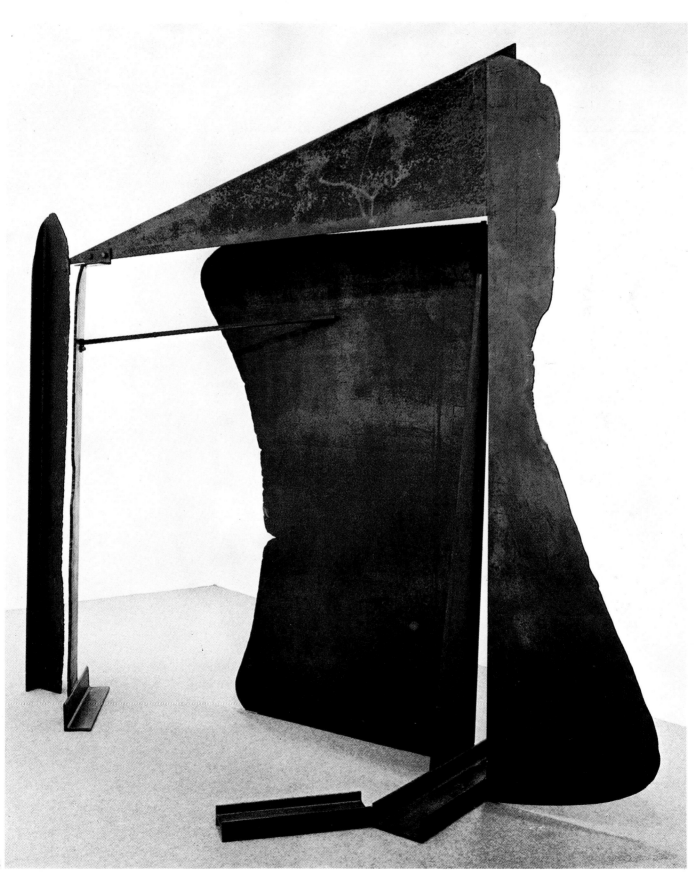

66 *Veduggio Plain*. 1972/73.
Steel rusted and varnished,
63'' × 90'' × 78'' / 160 × 228.5 × 198 cm.

67 *Durham Steel Flat*. 1973/74.
Steel rusted and varnished,
111½'' × 98½'' × 70½'' / 283 × 250 × 179 cm.

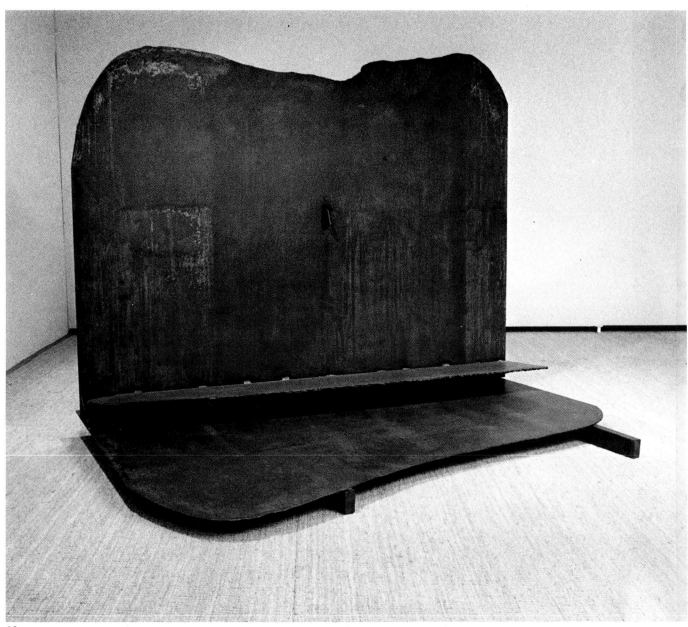

66

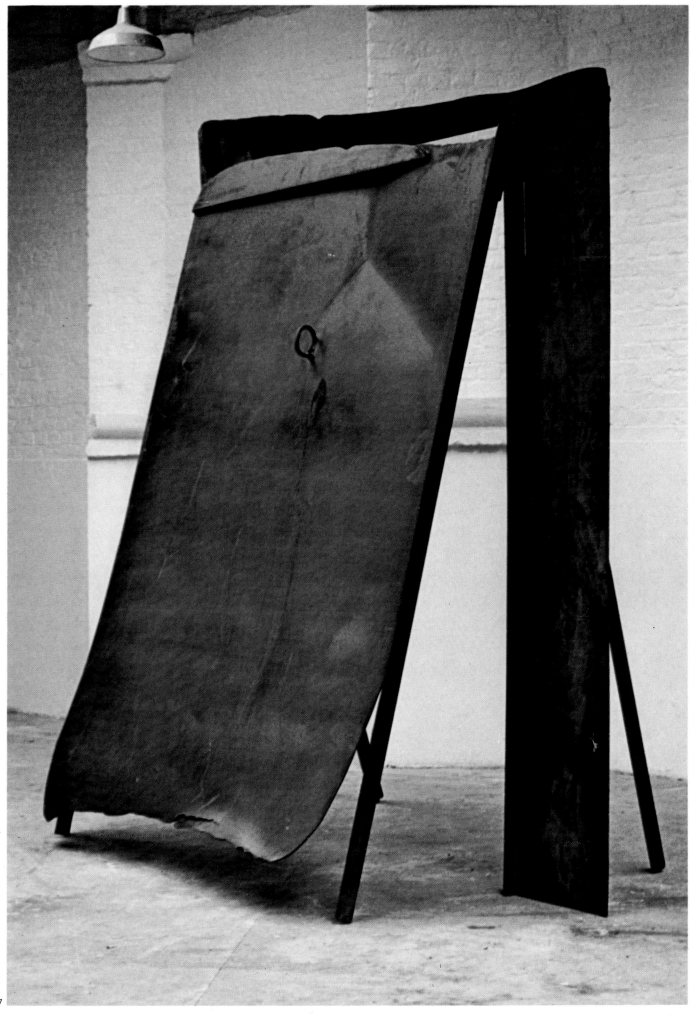

68 *Table Piece CLXXXIII*. 1974.
Steel varnished,
20″ × 78″ × 22″ / 50.8 × 198.1 × 55.9 cm.

69 *Table Piece CLXXXVI*. 1974.
Steel varnished,
18″ × 64″ × 25″ / 45.7 × 162.6 × 63.5 cm.

70 *Durham Purse*. 1973/74.
Steel rusted and varnished,
48″ × 147″ × 30″ / 122 × 373.5 × 76 cm.

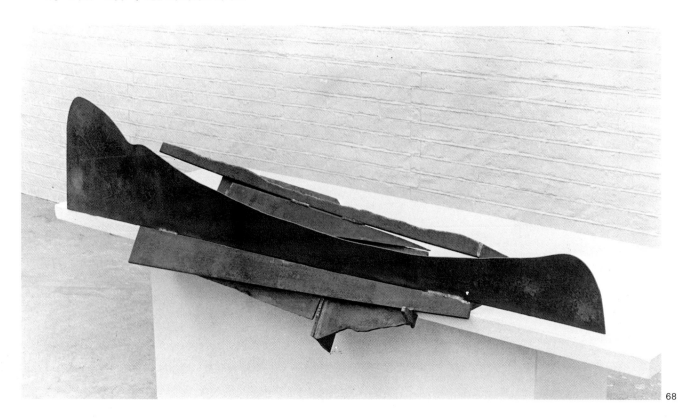

68

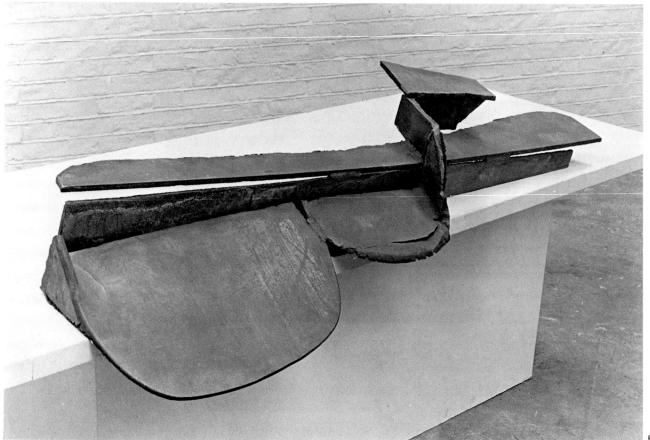

69

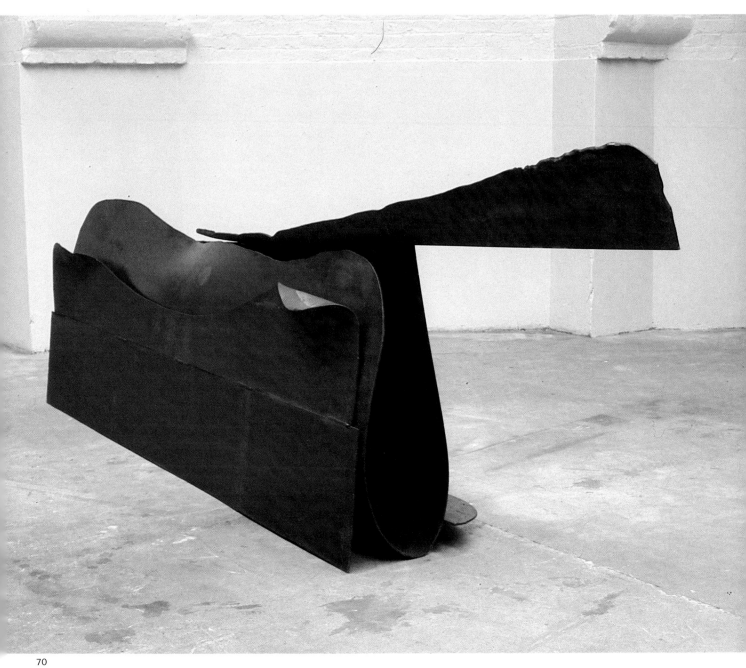

70

71 *Curtain Road*. 1974.
Steel rusted and varnished,
78'' × 188'' × 109'' / 198 × 475.5 × 277 cm.

72 *Surprise Flats*. 1974.
Steel rusted and varnished,
122'' × 136'' × 113'' / 310 × 345,5 × 287 cm.

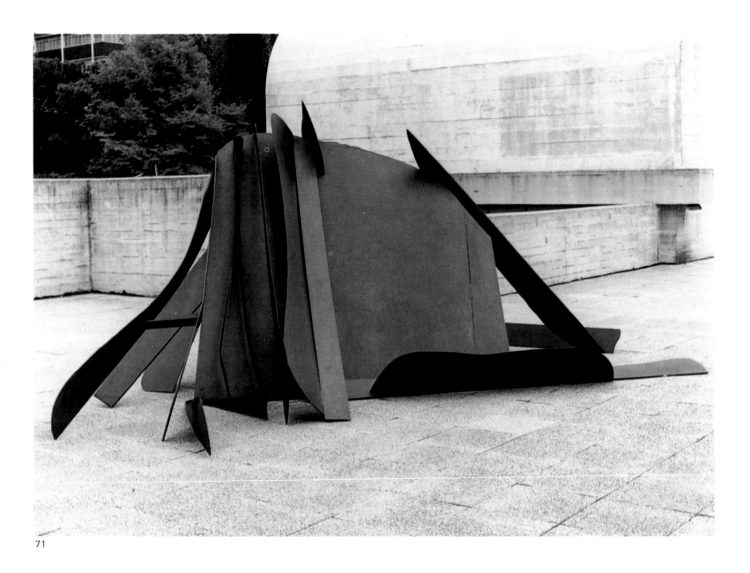

71

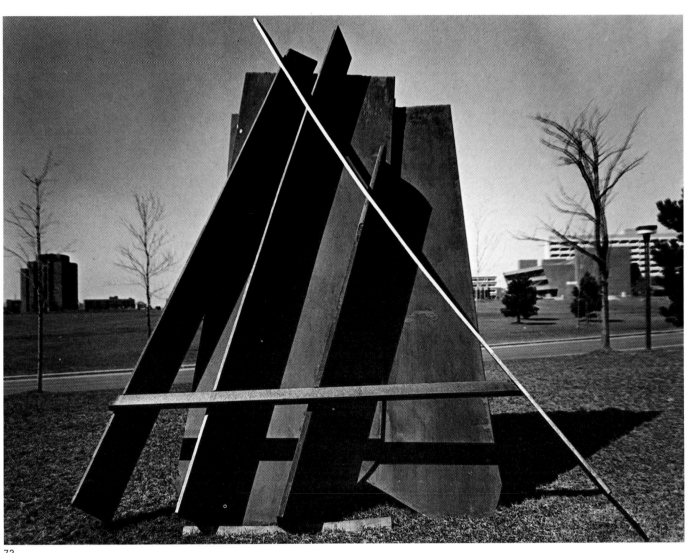

72

73 *Hot Dog Flats*. 1974.
Steel rusted and varnished,
78'' × 212'' × 81'' / 198 × 538,5 × 206 cm.

74 *Riviera*. 1971/74.
Steel rusted and varnished,
127'' × 325'' × 120'' / 322.5 × 825.5 × 305 cm.
Virginia Wright Fund, Seattle

75 *Sailing Tonight*. 1971/74.
Steel rusted and varnished,
63'' × 161'' × 26'' / 160 × 409 × 66 cm.

76 *Scheherazade*. 1974.
Steel rusted and varnished,
102½'' × 165'' × 108'' / 260.5 × 419 × 274.5 cm.

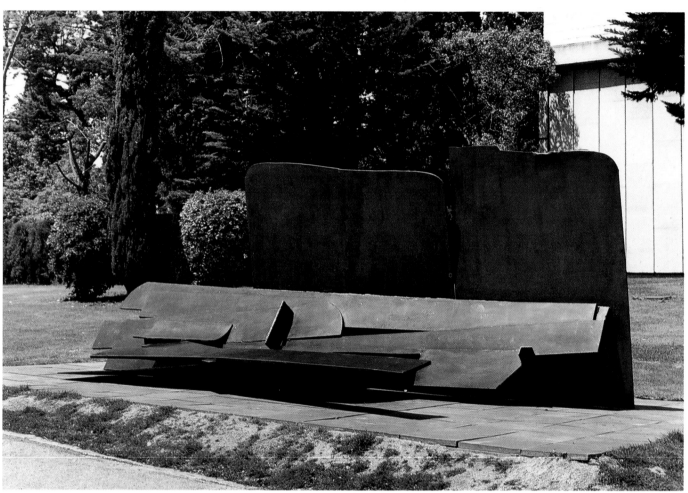

73

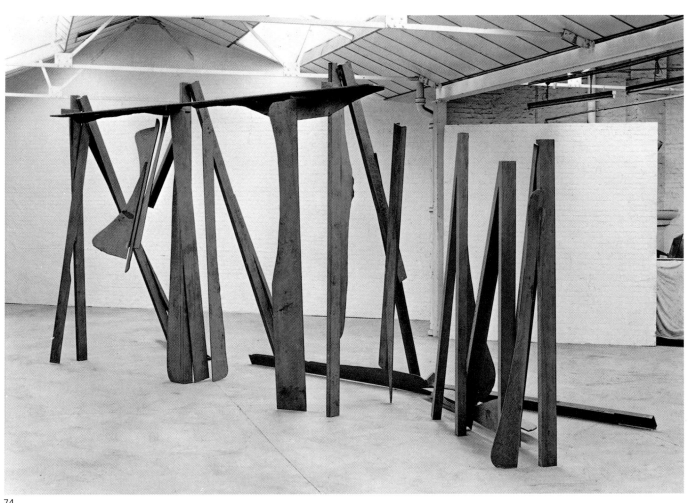

74

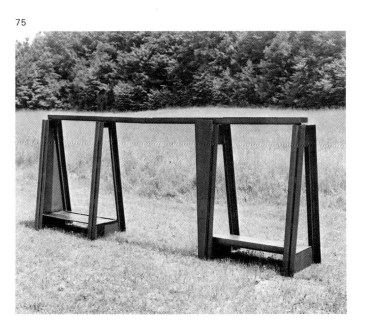

75

76

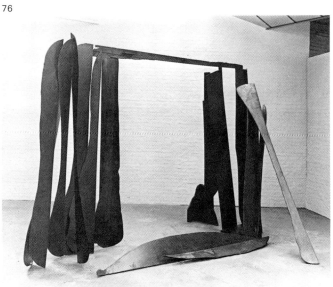

77 *Flank*. 1976.
Steel rusted and varnished,
74″ × 68″ × 67″ / 188 × 173 × 170 cm.

78 *Caramel*. 1975.
Steel,
58″ × 60″ × 35″ / 147.5 × 152.5 × 89 cm.

79 *Nectarine*. 1976.
Steel rusted and varnished,
79″ × 107″ × 51″ / 201 × 272 × 129.5 cm.

80 *Footprint*. 1975.
Steel,
85″ × 119″ × 66″ / 216 × 302.5 × 167.5 cm.

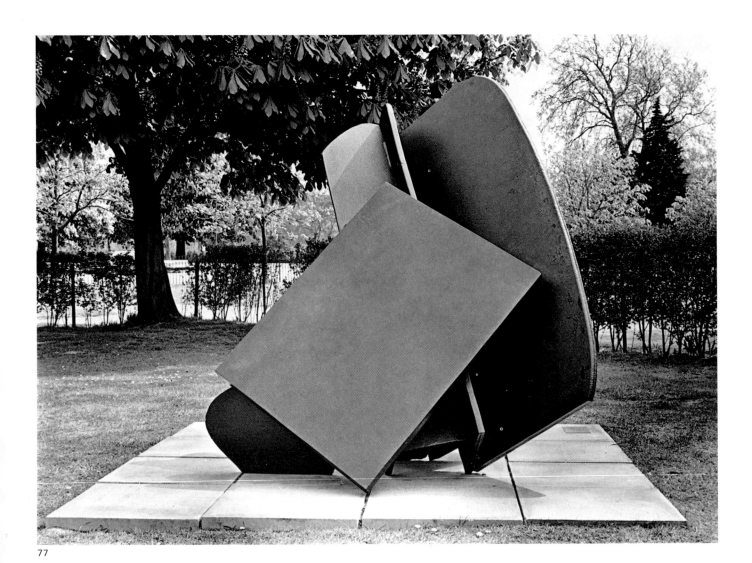

77

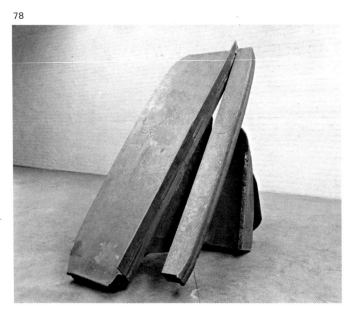

78

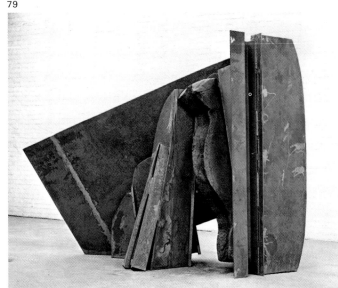

79

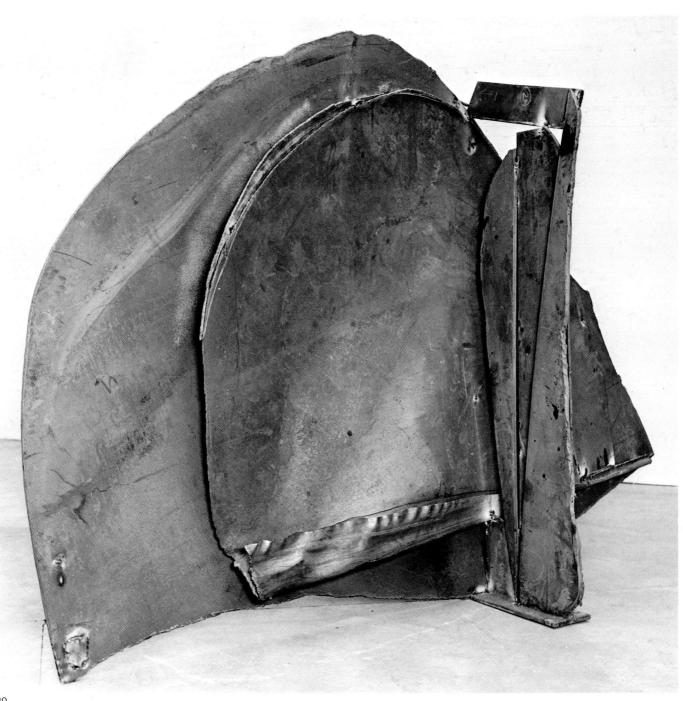

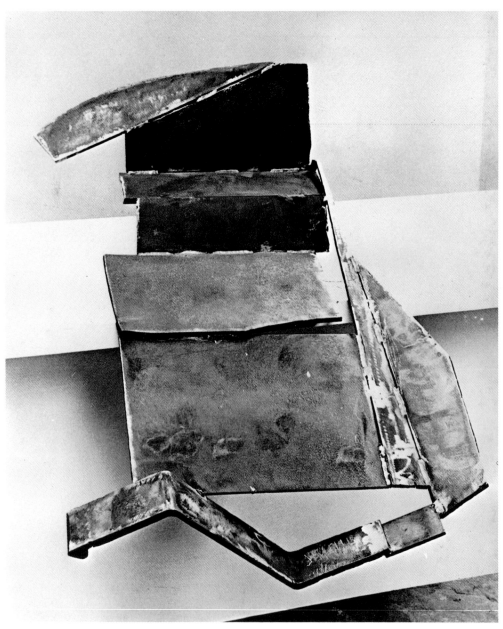

81

81 *Table Piece CXVI*. 1973.
Steel rusted and varnished,
32'' × 36'' × 25½''
81.3 × 91.4 × 64.8 cm.

82 *Table Piece CCXIII (Granada)*.
1974.
Steel rusted and varnished,
34'' × 55'' × 16''
86.4 × 139.7 × 40.6 cm.

83 *Table Piece CC*. 1974.
Steel varnished,
25½'' × 76½'' × 44''
64.8 × 194.3 × 111.8 cm.

84 *Table Piece CCIII*. 1974.
Steel varnished,
23'' × 90'' × 17''
58.4 × 228.6 × 43.2 cm.

85 *Piece CCXXVIII*. 1975.
Steel rusted and varnished,
17'' × 53'' × 15''
43.2 × 134.6 × 38.1 cm.

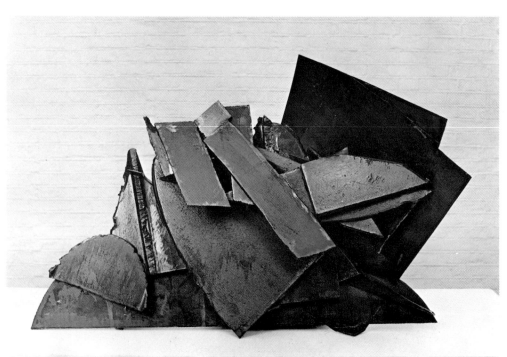

82

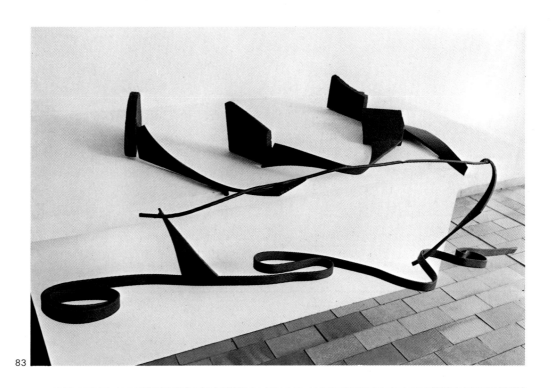

83

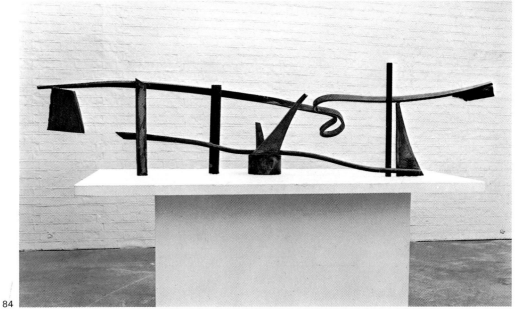

84

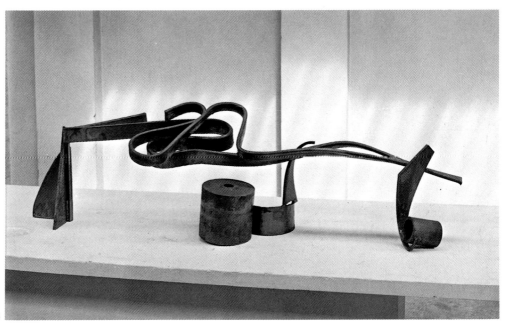

85

86 *Dumbfound*. 1976.
Bright steel painted green,
21'' × 50'' × 15'' / 53.5 × 127 × 38 cm.

87 *Slide Left*. 1976.
Steel rusted and varnished,
16½'' × 77'' × 23'' / 42 × 195.5 × 58.5 cm.

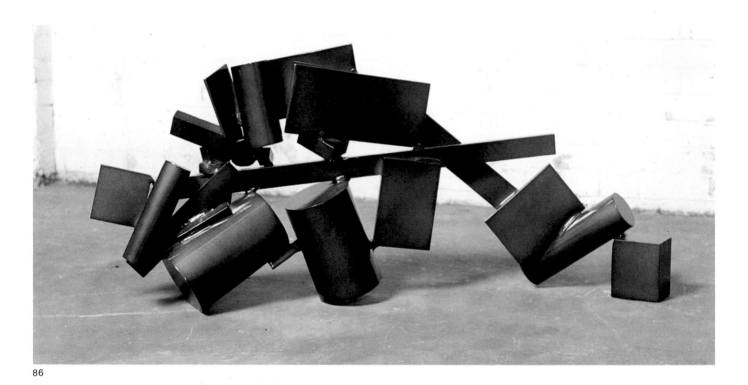

86

87

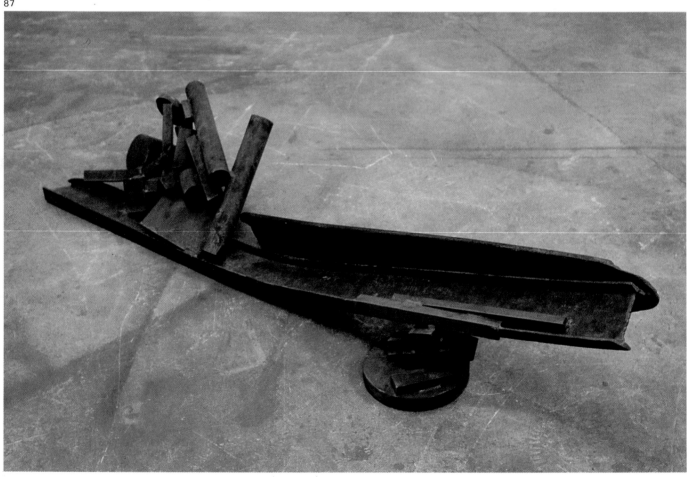

88 *Table Piece CCXLVII*. 1975.
Steel rusted and varnished,
27″ × 56″ × 20″ / 68.6 × 142.2 × 50.8 cm.

89 *Table Piece CCC*. 1975/76.
Steel and sheet steel rusted and varnished,
38½″ × 52″ × 13″ / 97.8 × 132.1 × 33 cm.

90 *Table Piece CCLXII*. 1975.
Steel and sheet steel rusted and varnished,
20″ × 40″ × 26″ / 50.8 × 101.6 × 66 cm.

91 *Table Piece CCLXXX*. 1975/76.
Steel rusted and varnished,
31″ × 59½″ × 23½″ / 78.7 × 151.1 × 59.7 cm.

92 *Floor Piece C 38*. 1975/76.
Steel rusted and varnished,
28″ × 58″ × 36″ / 71.1 × 147.3 × 91.5 cm.

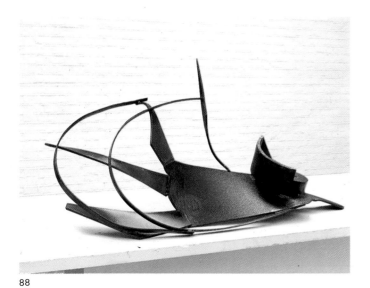

88

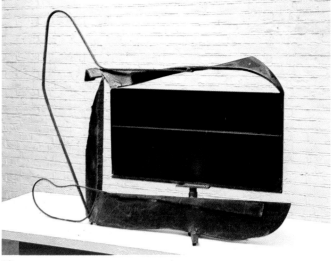

89

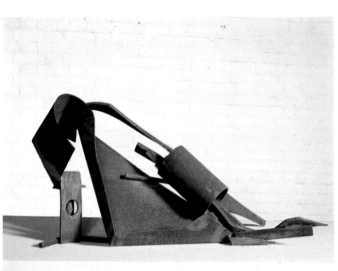

90

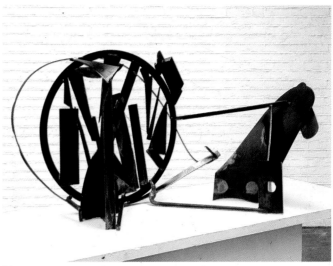

91

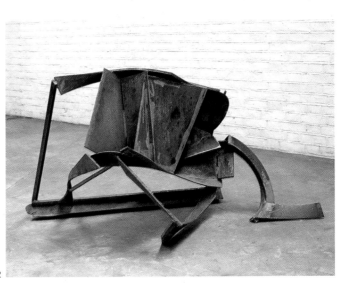

92

93 *Midnight Gap*. 1976/78.
Steel rusted, varnished and painted green,
71″ × 142″ × 110″ / 180.5 × 361 × 279 cm.

94 *Fathom*. 1976.
Steel rusted and varnished,
81″ × 305″ × 66″ / 206 × 775 × 167.5 cm.

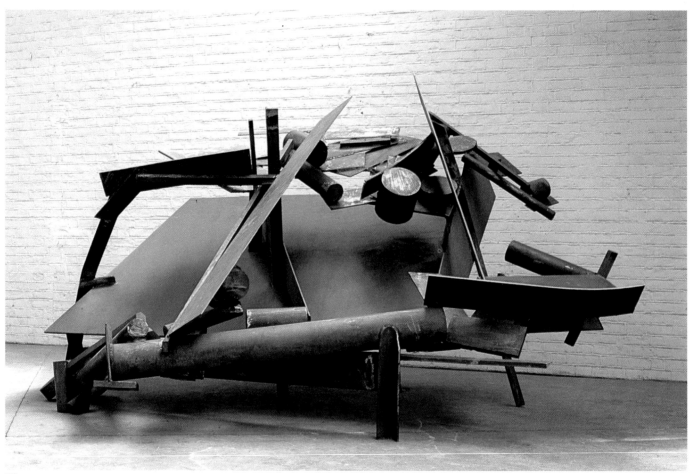

93

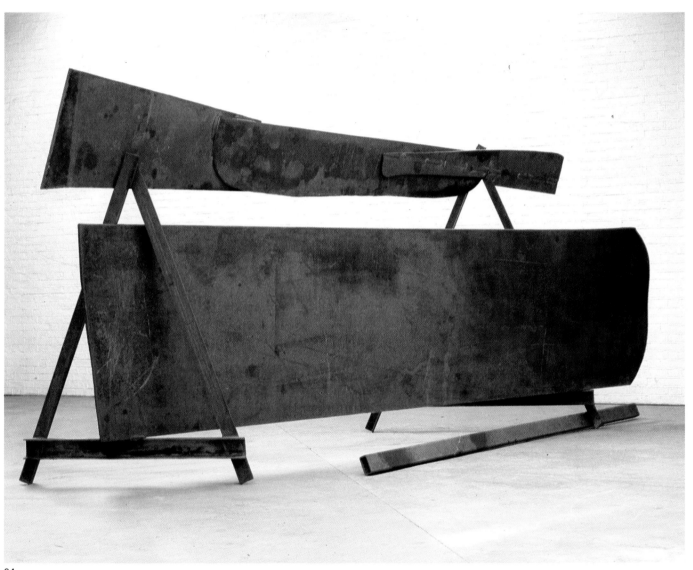

94

95 *Emma This*. 1977.
Steel rusted, painted red and blacked,
59'' × 102'' × 73'' / 150 × 259 × 185.5 cm.

96 *Emma That*. 1977.
Steel rusted, painted red and blacked,
52½'' × 56'' × 107'' / 133.5 × 142 × 272 cm.

97 *Emma Dipper*. 1977.
Steel rusted and painted grey,
84'' × 67'' × 126'' / 213.5 × 170 × 320 cm.

98 *Emma Dance*. 1977/78.
Steel rusted, painted and blacked,
94½'' × 98'' × 111'' / 240 × 249 × 282 cm.

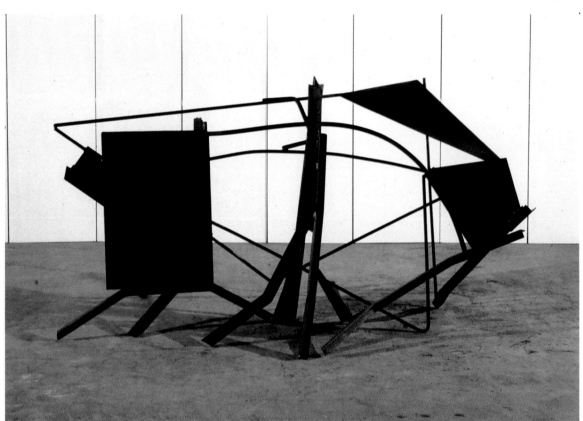

95

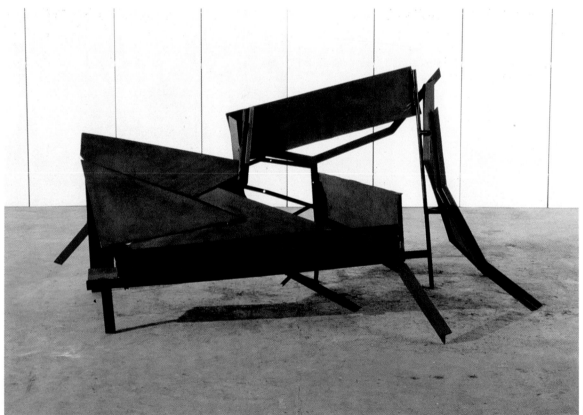

96

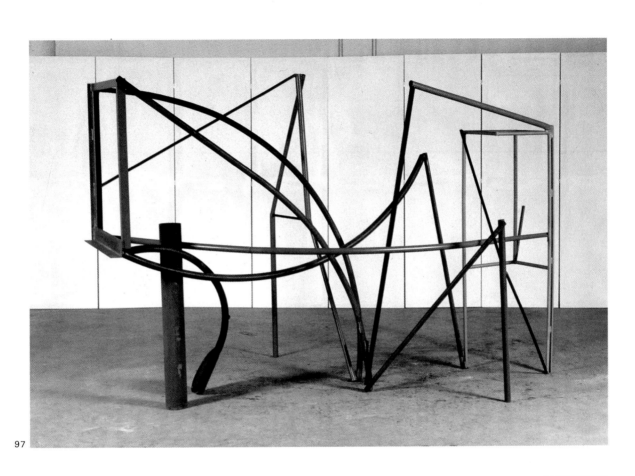

97

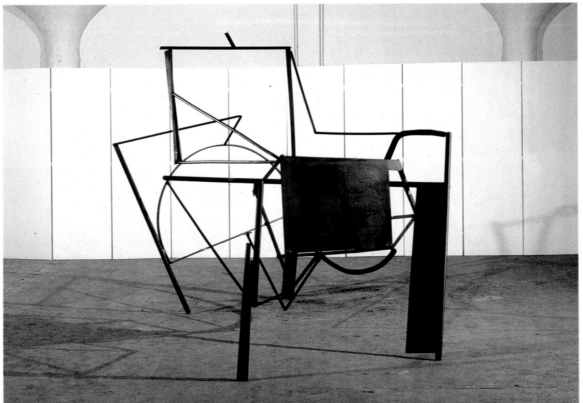

98

99

100

101

99-102 *National Gallery Ledge Piece*. 1977.
Steel rusted and painted grey,
174″ × 235″ × 107″ / 442 × 597 × 272 cm.

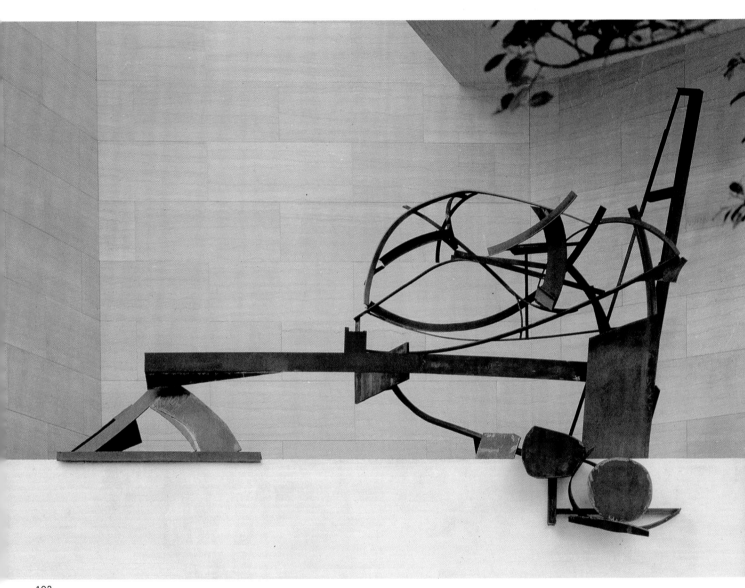

102

103 *Floor Piece C 92 (Medicine Hat)*. 1975/77.
Steel and sheet steel and galvanised
wire, painted and sprayed grey,
30″ × 60″ × 39″ / 76.2 × 152.4 × 99.1 cm.

104 *Table Piece CCCLIV*. 1976/77.
Steel rusted and varnished,
23¾″ × 57″ × 13½″ / 59.1 × 144.8 × 34.3 cm.

105 *Table Piece CCCXIII*. 1976/77.
Steel and sheet steel rusted and varnished,
30″ × 40″ × 14″ / 76.2 × 101.6 × 35.6 cm.

106 *Table Piece CCCX*. 1976/77.
Steel rusted and varnished,
20″ × 63″ × 39″ / 50.8 × 160 × 99.1 cm.

107 *Table Piece CCCXXXII (Rosette)*. 1976/77.
Steel and cast iron, rusted and varnished,
13″ × 28″ × 22″ / 33 × 71.1 × 55.9 cm.

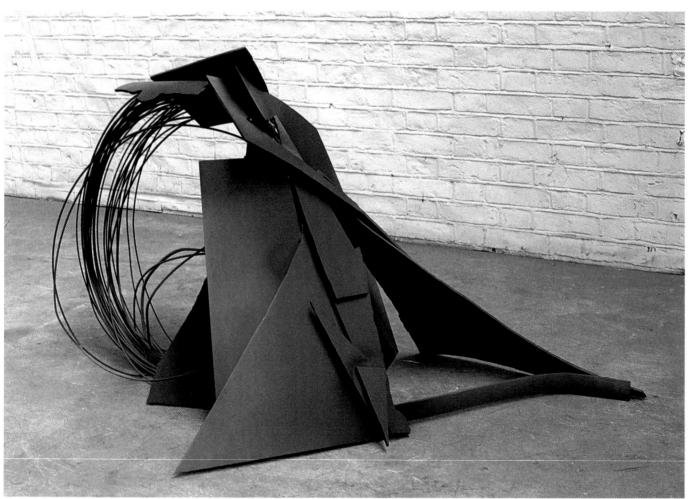

103

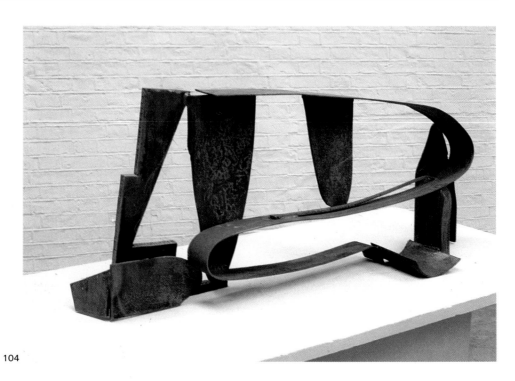

104

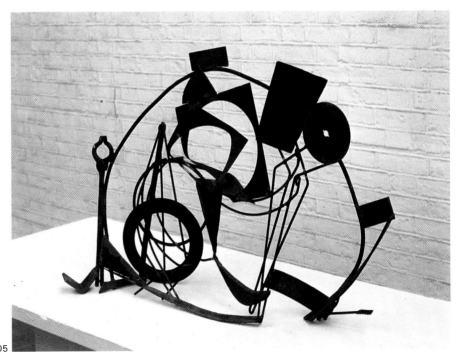

105

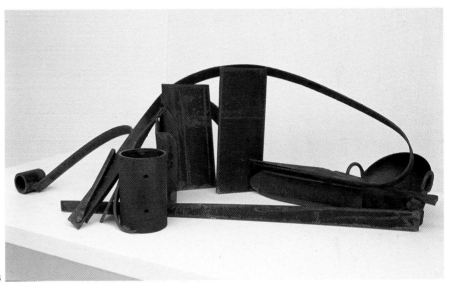

106

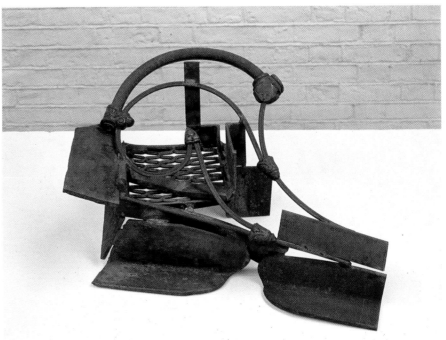

107

108 *Table Piece CCCC (Four C'S).* 1977/78.
Steel rusted and varnished,
42½'' × 59'' × 22¾'' / 107 × 150 × 58 cm.

109 *Table Piece CCCLXXXVIII.* 1977.
Steel rusted and varnished,
40½'' × 44'' × 21'' / 102.9 × 111.8 × 53.3 cm.

108

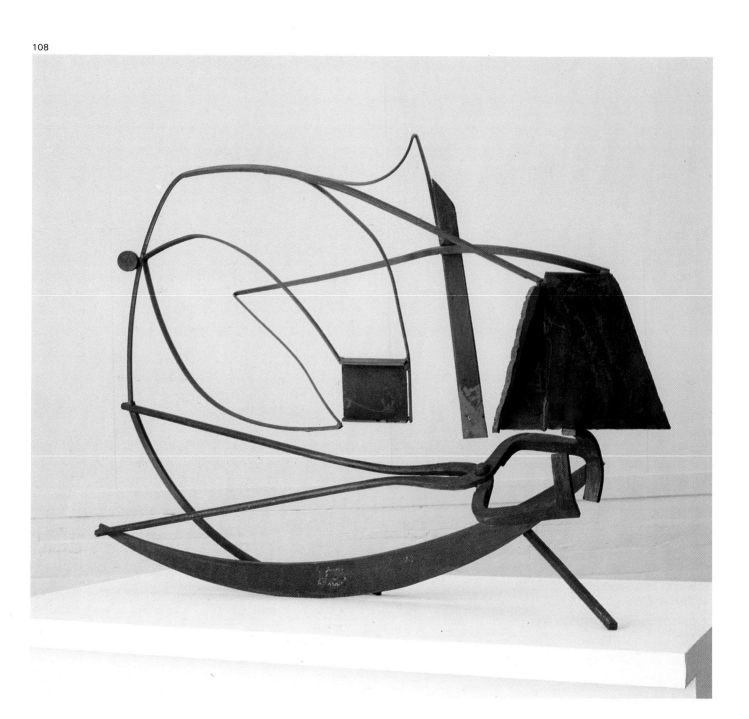

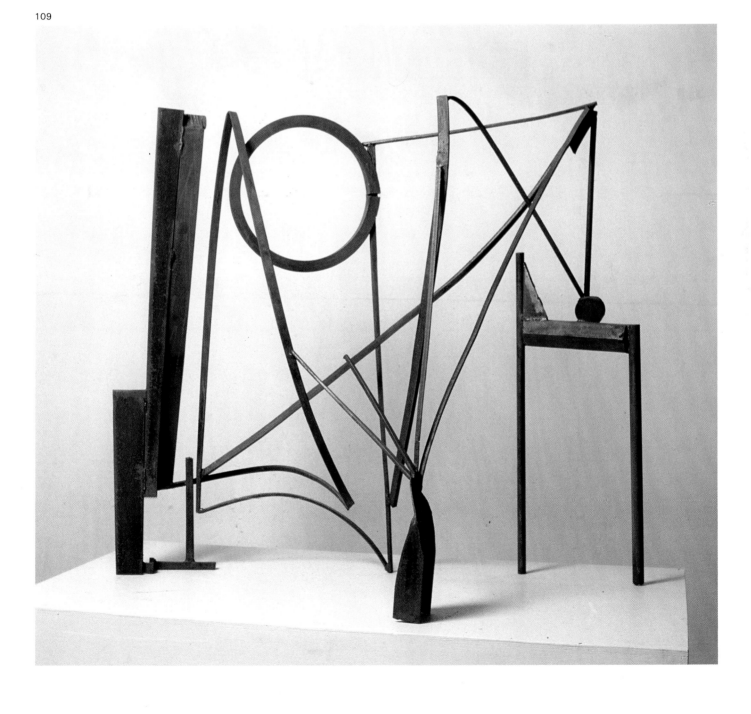

110 *Paper Sculpture No. 105
(Punch and Judy).* 1981.
Pencil, chalk, acrylic, 4 push pins, Tycore, handmade
paper in wood box,
34½'' × 21'' × 8½'' / 87.6 × 53.3 × 21.6 cm.

111 *Paper Sculpture No. 24 (As You Are).* 1981.
Pencil, acrylic, handmade paper on Tycore,
38¼'' × 24'' × 4'' / 97.2 × 61 × 10.2 cm.

112 *Paper Sculpture No. 97.* 1981.
Pencil, acrylic, spray paint, handmade paper on Tycore,
25½'' × 25½'' × 6½'' / 64.8 × 64.8 × 16.5 cm.

113 *Paper Sculpture No. 4 (Big White).* 1981.
Pencil, chalk, acrylic, handmade paper on Tycore,
32'' × 38⅜'' × 7½'' / 81.3 × 97.5 × 19 cm.

110

111

112

113

114 *Great Jones Landscape*. 1983.
Stoneware coloured and painted,
8'' × 38'' × 19'' / 20.5 × 96.5 × 48 cm.

115 *Great Jones Triangle*. 1983.
Stoneware coloured and painted,
12½'' × 26'' × 20¾'' / 31.5 × 66 × 52.5 cm.

116 *Can Co Galore*. 1977.
Stoneware,
8'' × 11'' × 25'' / 20.3 × 27.9 × 62.5 cm.

117 *Can Co Cut*. 1975/76.
Stoneware,
12'' × 13'' × 36'' / 30.5 × 33 × 91.4 cm.

114

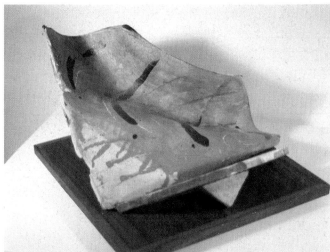

115

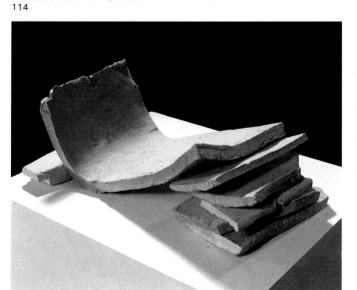

116

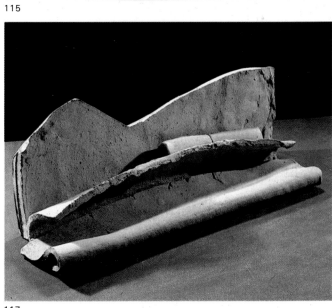

117

118 *Mint Chiffon*. 1978/79.
Bronze cast and welded,
54'' × 33'' × 24'' / 137.2 × 83.8 × 61 cm.

119 *Buddha Peach*. 1976/78.
Bronze cast and welded,
36¾'' × 24'' × 20'' / 93.5 × 61 × 50.8 cm.

120 *Table Bronze the Mosque*. 1979/80.
Bronze cast and and welded, and brass,
33½'' × 37'' × 29½'' / 85.1 × 94 × 75 cm.

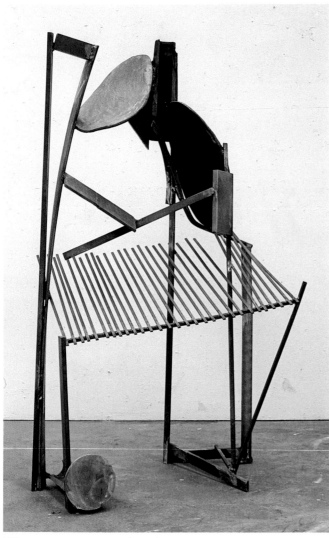

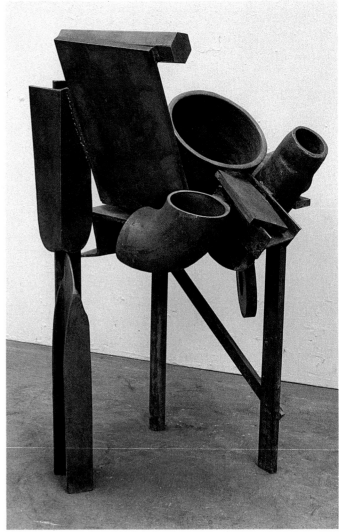

118

119

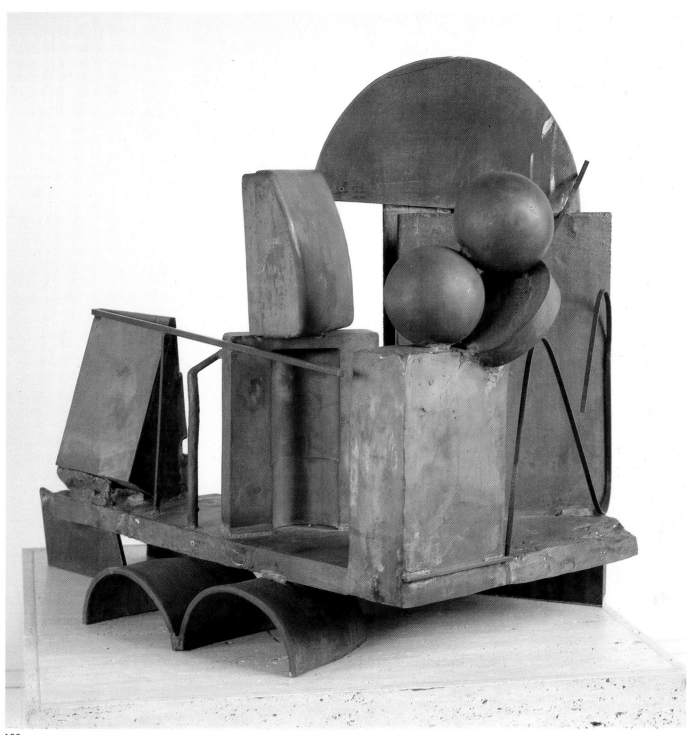

121 *Stainless Piece A-F*. 1979.
Stainless steel,
16½″ × 43″ × 30″ / 41.9 × 109.2 × 76.2 cm.

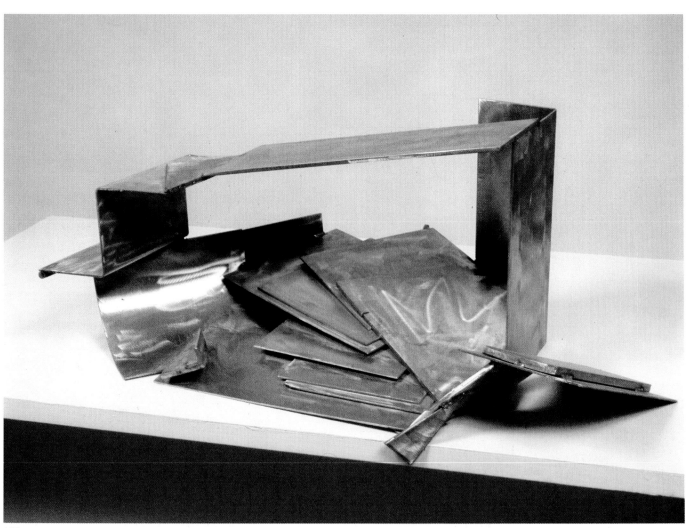

121

122 *Writing Piece "Bake"*. 1979.
Steel rusted and blacked,
13″ × 28″ × 11″ / 33 × 71.1 × 27.9 cm.

123 *Writing Piece "Blank"*. 1979.
Steel,
12½″ × 33″ × 11½″ / 31.8 × 83.8 × 29.2 cm.

124 *Writing Piece "Were"*. 1979.
Steel,
27″ × 40″ × 12″ / 68.6 × 101.6 × 30.5 cm.

125 *Writing Piece "Good"*. 1979.
Steel, cast iron and wood, painted,
24½″ × 14″ × 19″ / 62.2 × 35.6 × 48.3 cm.

126 *Writing Piece "Whence"*. 1978.
Steel rusted, painted and blacked,
12½″ × 34″ × 6½″ / 31.7 × 86.4 × 16.5 cm.

127 *Table Piece Z-18 (Balcarres)*. 1980.
Steel rusted and varnished,
13″ × 57″ × 13″ / 33 × 144.8 × 33 cm.

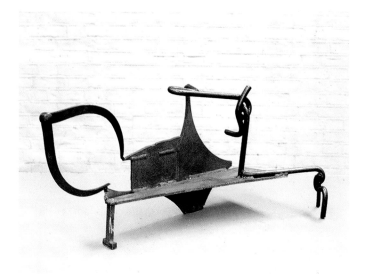

122

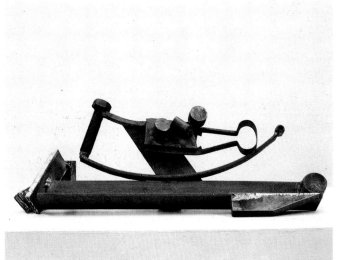

123

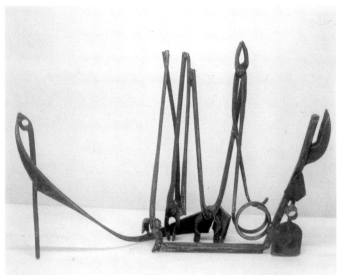

124

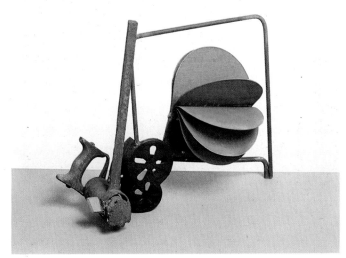

125

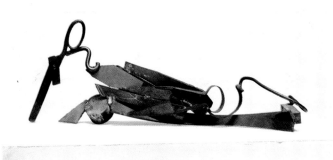

126

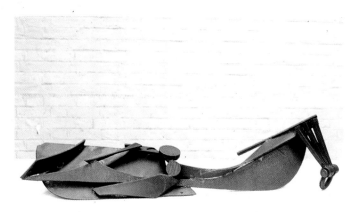

127

128 *Half Dollar*. 1980.
Bronze cast and welded, and brass,
27½'' × 25½'' × 22''
70 × 64.8 × 55.9 cm.

129 *Late Quarter*. 1979.
Bronze cast and welded, and brass,
13'' × 16'' × 20''
33 × 40.6 × 50.8 cm.

130 *Half Moon*. 1980.
Bronze cast and welded, and brass,
28½'' × 31'' × 20½''
72.4 × 78.7 × 52.1 cm.

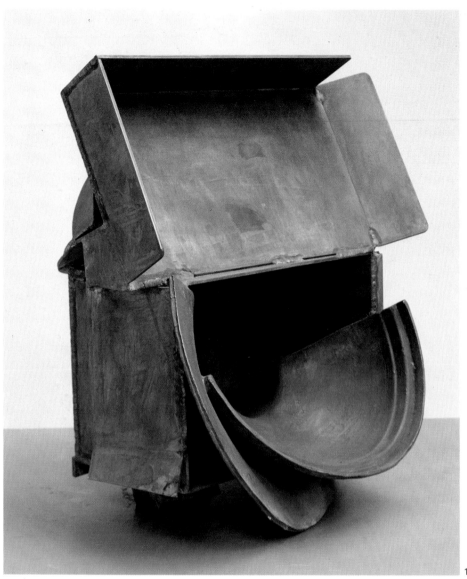

128

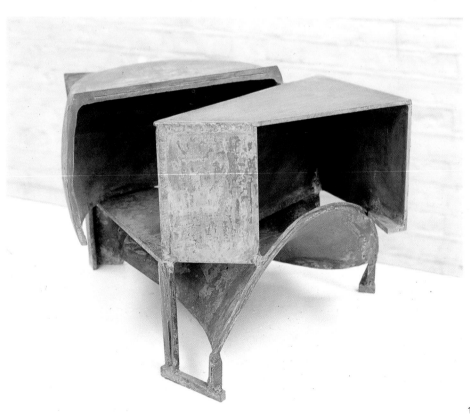

129

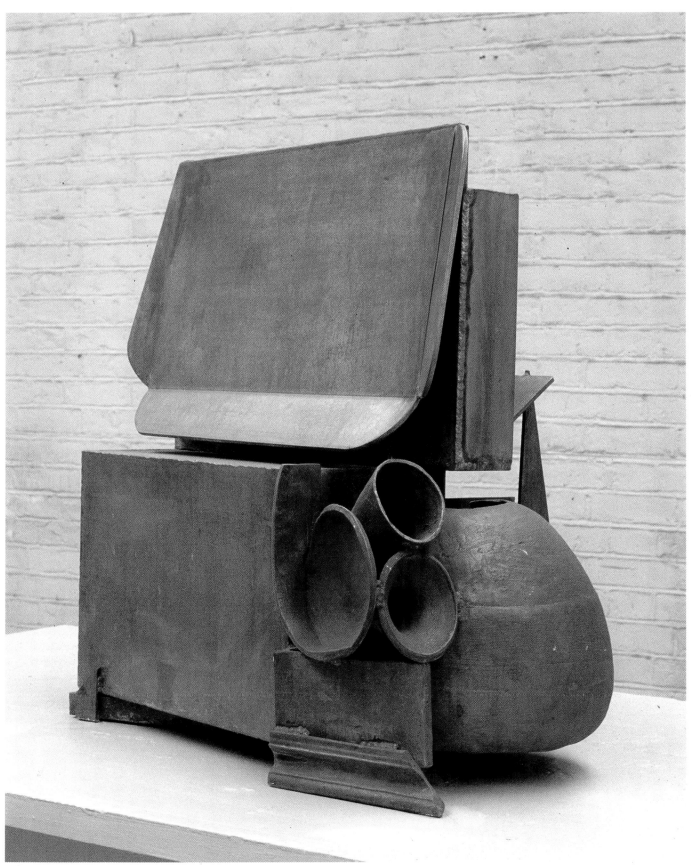

131 *Water Street Table Bronze Starter*. 1980.
Bronze cast and welded,
22'' × 24'' × 17'' / 55.9 × 61 × 43.2 cm.

132 *Water Street Straddle*. 1980.
Bronze cast and welded, copper and brass sheet,
36'' × 52'' × 30'' / 91.4 × 132.1 × 76.2 cm.

133 *Water Street Return*. 1980.
Bronze cast and welded, and copper,
48'' × 30'' × 20'' / 121.9 × 76.2 × 50.8 cm.

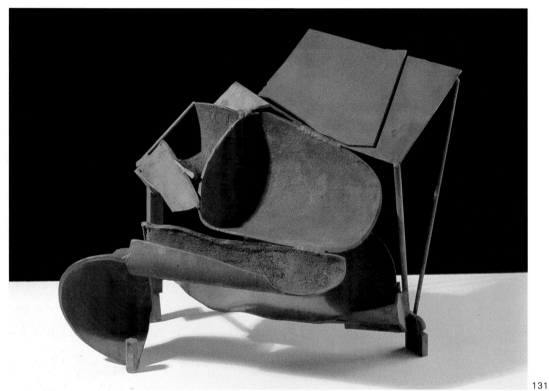

131

132

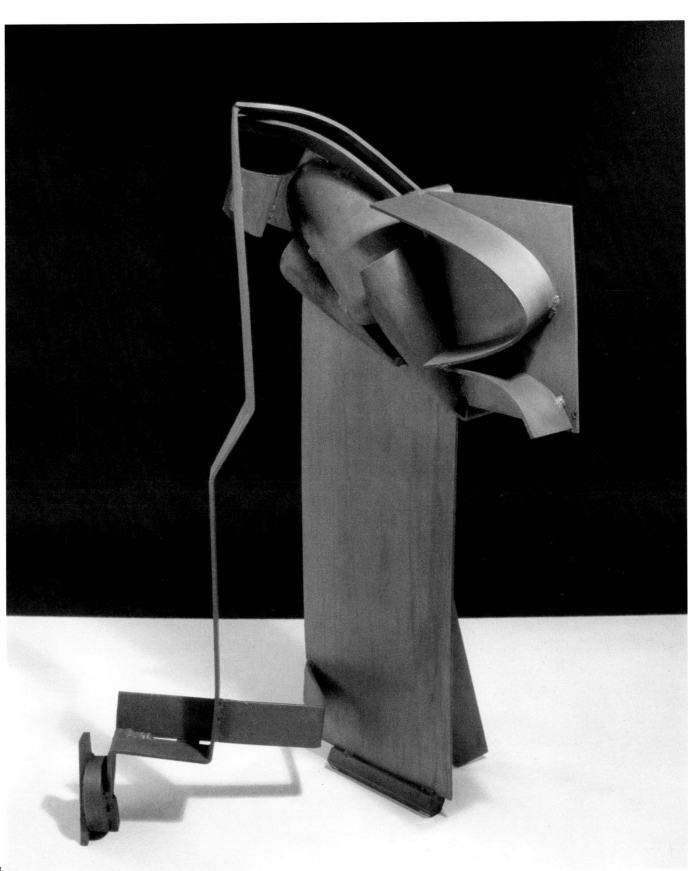

134 *Bronze Screen ''Gala''*. 1981.
Bronze cast and welded,
70'' × 49'' × 20½'' / 178 × 124.5 × 52 cm.

135 *Bronze Screen ''Return''*. 1981.
Bronze cast and welded,
66'' × 37'' × 18'' / 167.5 × 94 × 45.5 cm.

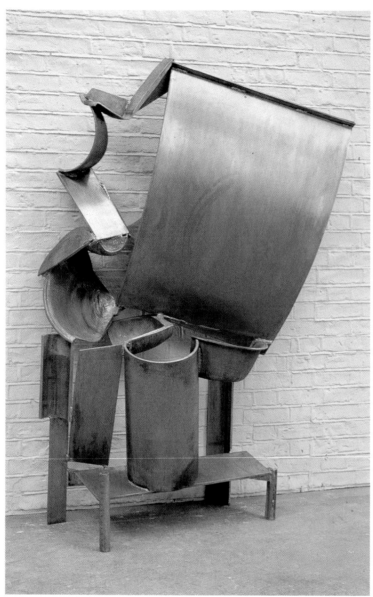

134

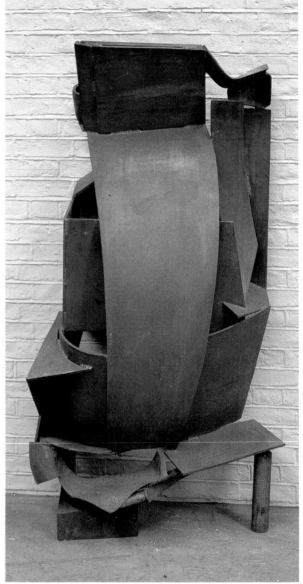

135

136 *Bronze Screen "Quiver".* 1981.
Bronze cast and welded,
71½'' × 46'' × 23½'' / 181.5 × 117 × 60 cm.

137 *Bronze Screen "Lattice".* 1981.
Bronze cast and welded,
68'' × 45'' × 18'' / 172.5 × 114.5 × 45.5 cm.

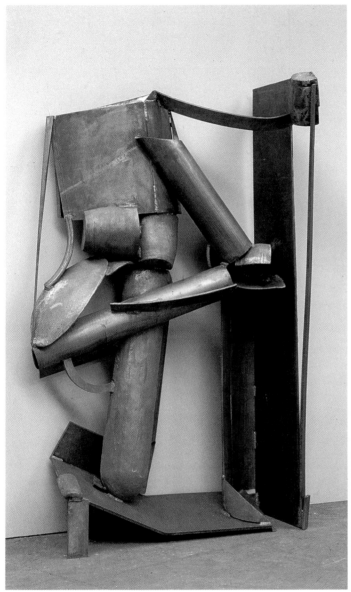

136

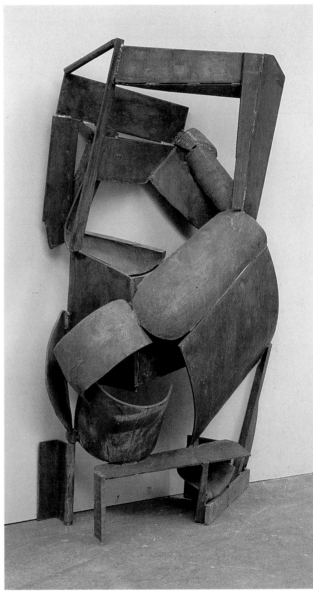

137

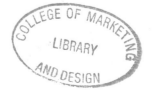

138 *Bronze Screen ''Round Up''*. 1981.
Bronze cast and welded,
71'' × 62'' × 40'' / 180.5 × 157.5 × 102 cm.

139 *Mack Centre*. 1984.
Steel,
28'' × 62'' × 36'' / 71 × 157.5 × 91.5 cm.

140 *Mid Centre*. 1984.
Steel,
33'' × 46'' × 35'' / 84 × 117 × 89 cm.

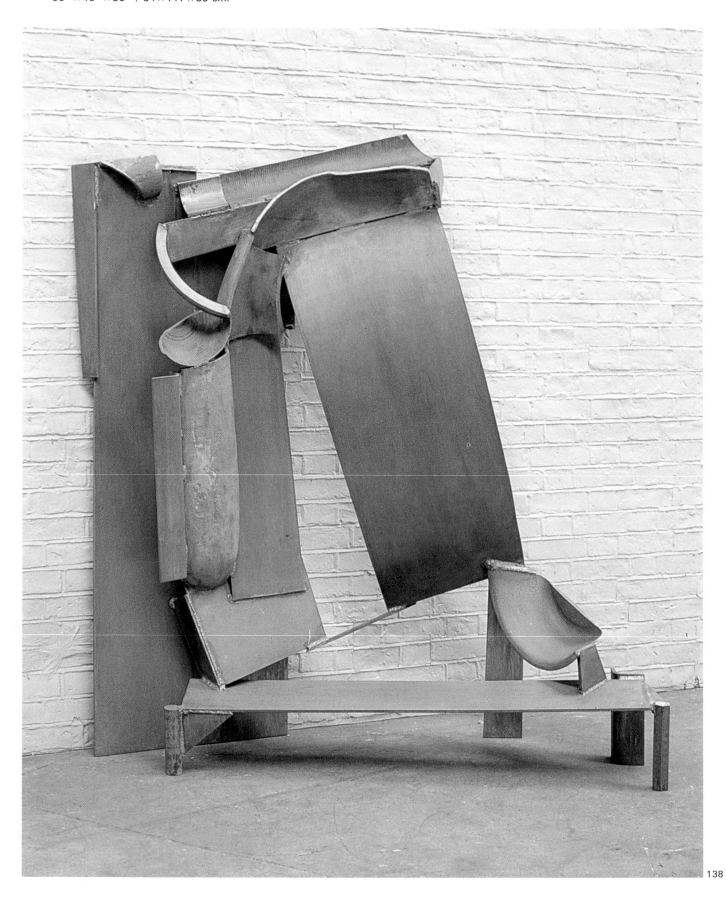

139

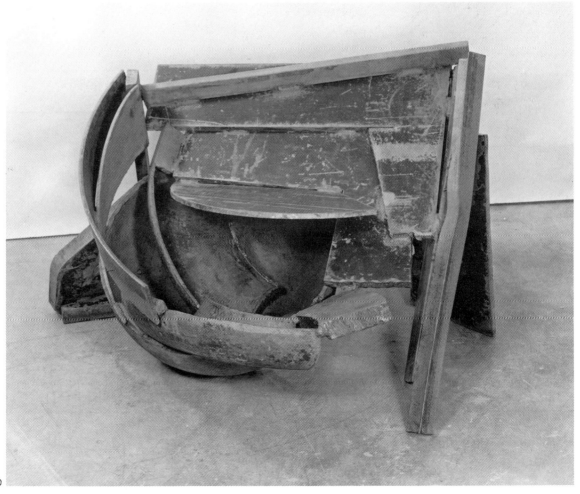

140

141 *Plains Open*. 1982.
Steel,
31'' × 35'' × 25'' / 78.5 × 89 × 63.5 cm.

142 *Plains Heat*. 1982.
Steel,
34'' × 38'' × 29'' / 86.5 × 96.5 × 73.5 cm.

143 *Pine Hollow*. 1983.
Steel,
25'' × 36'' × 21'' / 63.5 × 91.5 × 53.5 cm.

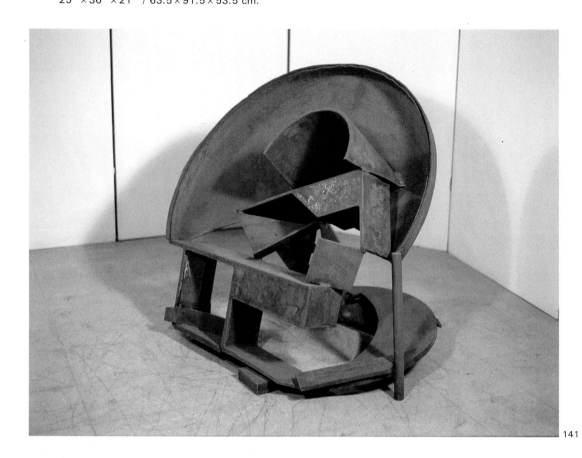

141

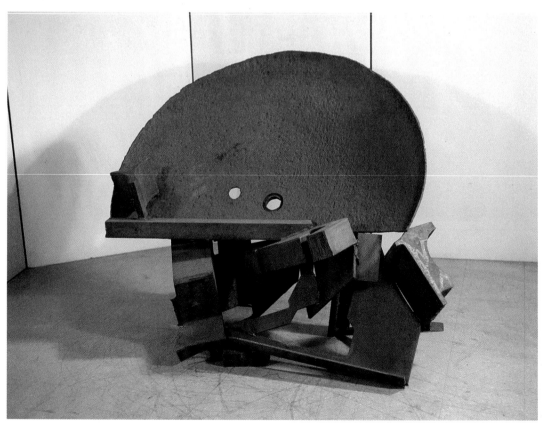

142

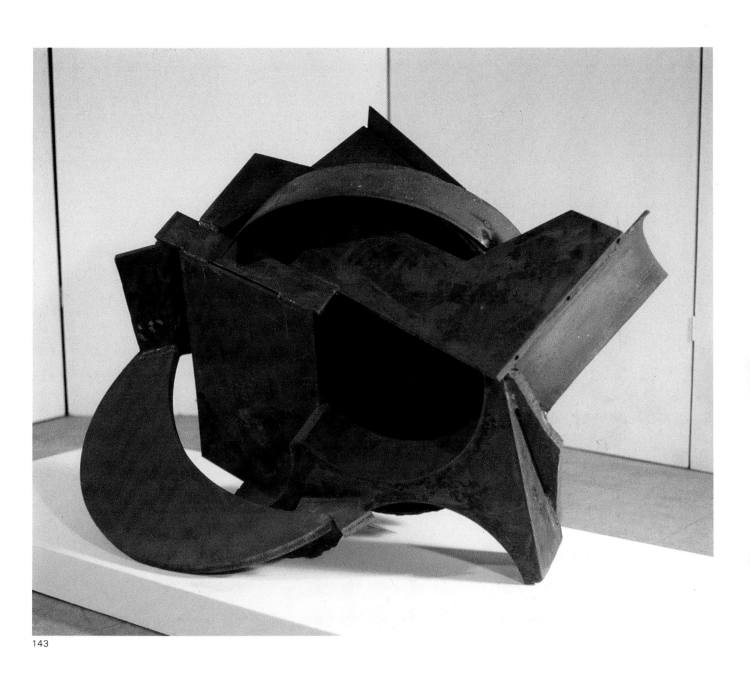

143

144 *Table Piece Y-2 ''Seascape''*. 1982/84.
Steel and stainless steel, painted,
15'' × 44½'' × 13½'' / 38 × 113 × 34 cm.

145 *On the Double*. 1981.
Lead and wood, painted,
25'' × 26'' × 12½'' / 63.5 × 66 × 32 cm.

146 *Silver Piece XV ''Bridge of Sounds''*. 1984.
Silver,
8¾'' × 14½'' × 7½'' / 19.5 × 37 × 19 cm.

144

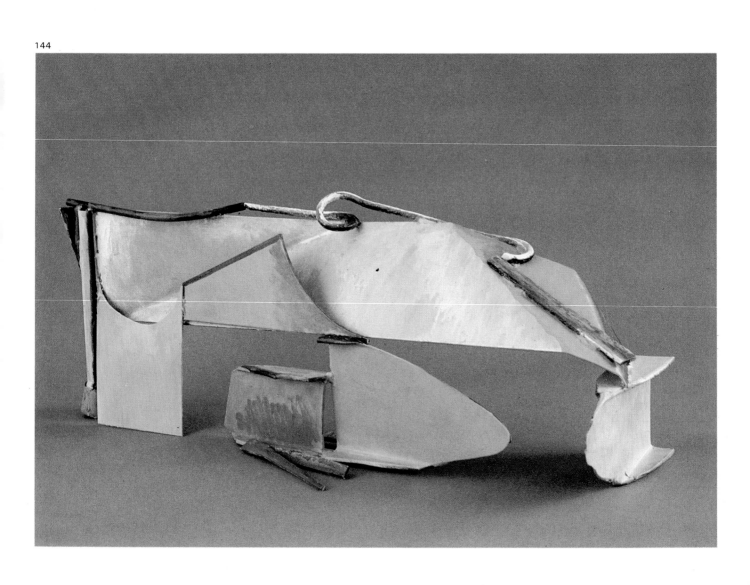

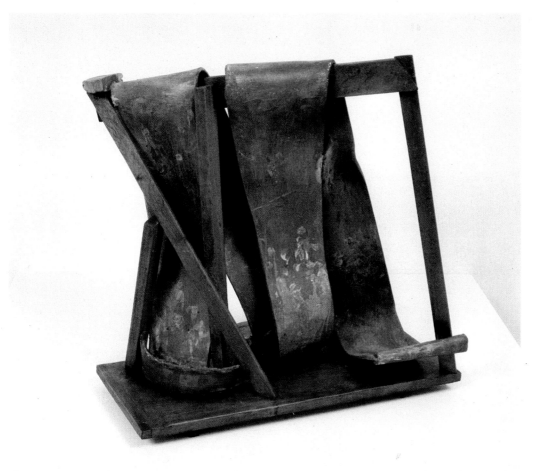

145

146

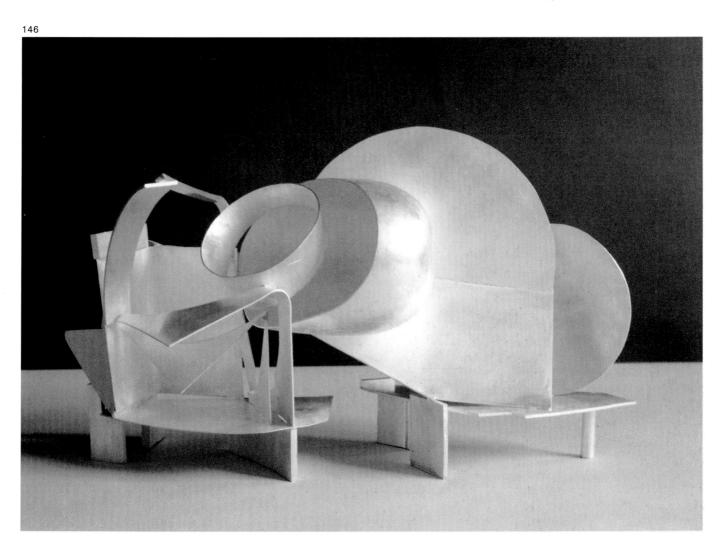

147 *Centre Court*. 1980/81.
Bronze cast and welded, and brass,
29″ × 38″ × 33½″ / 73.7 × 96.5 × 85.1 cm.

148 *Half and Half*. Table Bronze. 1981.
Bronze cast and welded, and brass,
26″ × 45″ × 24″ / 66 × 114.5 × 61 cm.

149 *Double Half*. Table Bronze. 1982/83.
Bronze cast and welded, and brass,
24″ × 44″ × 29″ / 61 × 112 × 73.5 cm.

150 *The River*. 1982/83.
Bronze cast and welded, and brass,
57½″ × 49½″ × 31″ / 146 × 125.5 × 78.5 cm.

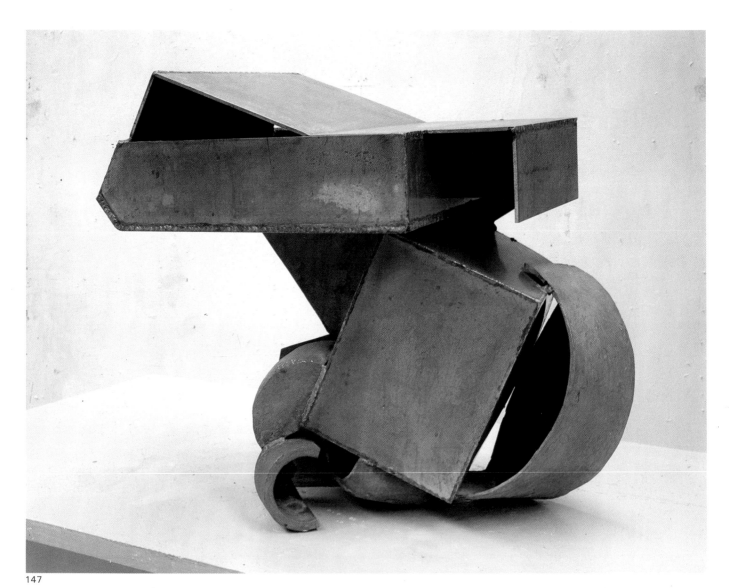

147

148

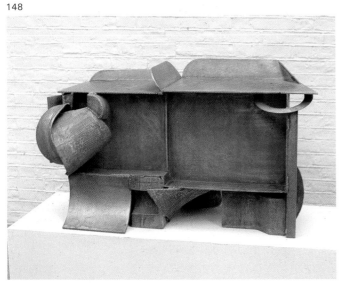

149

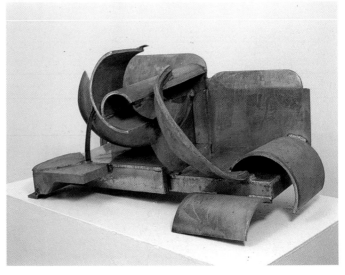

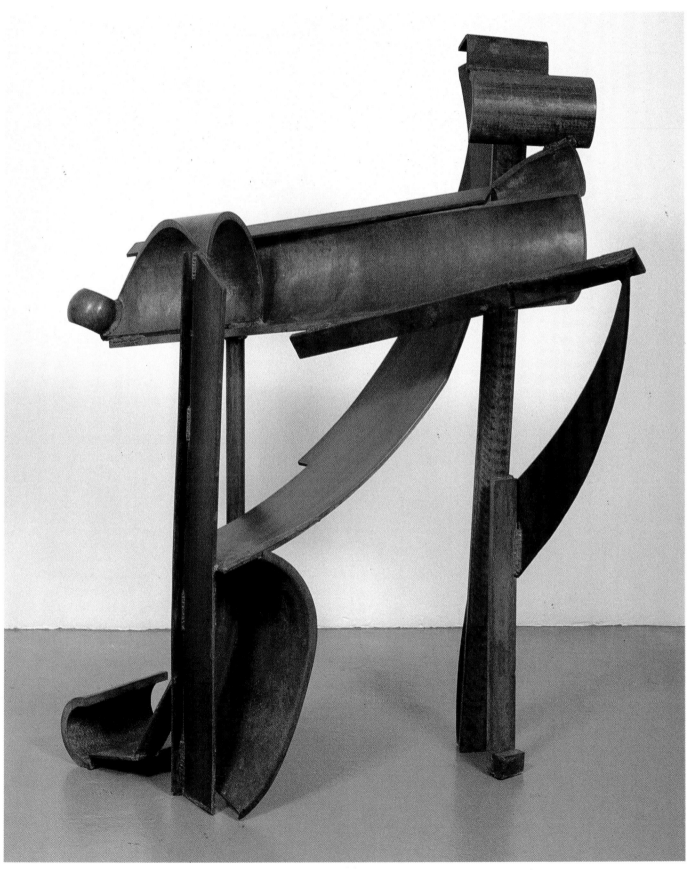

151 *Table Piece Z-92 ''Billow''*. 1982.
Steel blacked, rusted and varnished,
24½'' × 40'' × 25½'' / 62 × 102 × 64.5 cm.

152 *Table Piece Z-87 ''Breaker''*. 1982.
Steel rusted and varnished,
25½'' × 49½'' × 31½'' / 64.5 × 125.5 × 80 cm.

153 *Table Piece Y-16*. 1983.
Steel rusted and varnished,
33½'' × 29'' × 20'' / 85 × 73.5 × 51 cm.

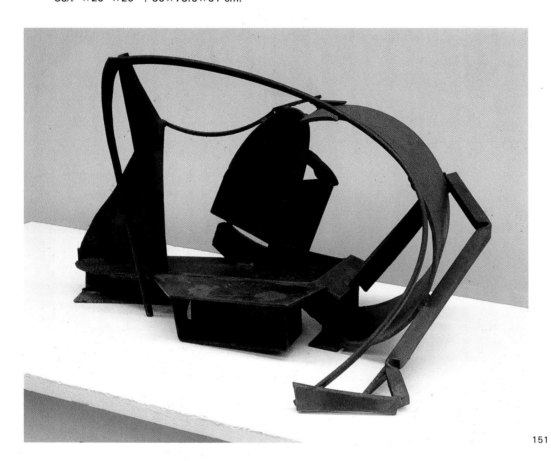

151

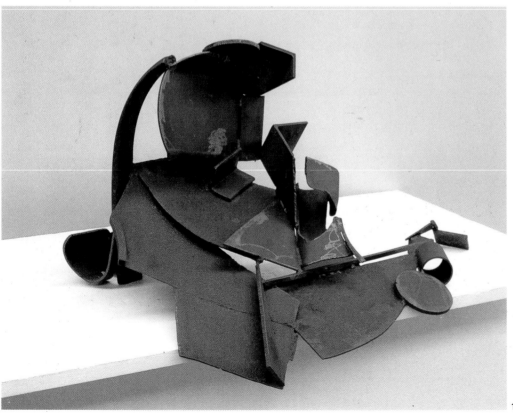

152

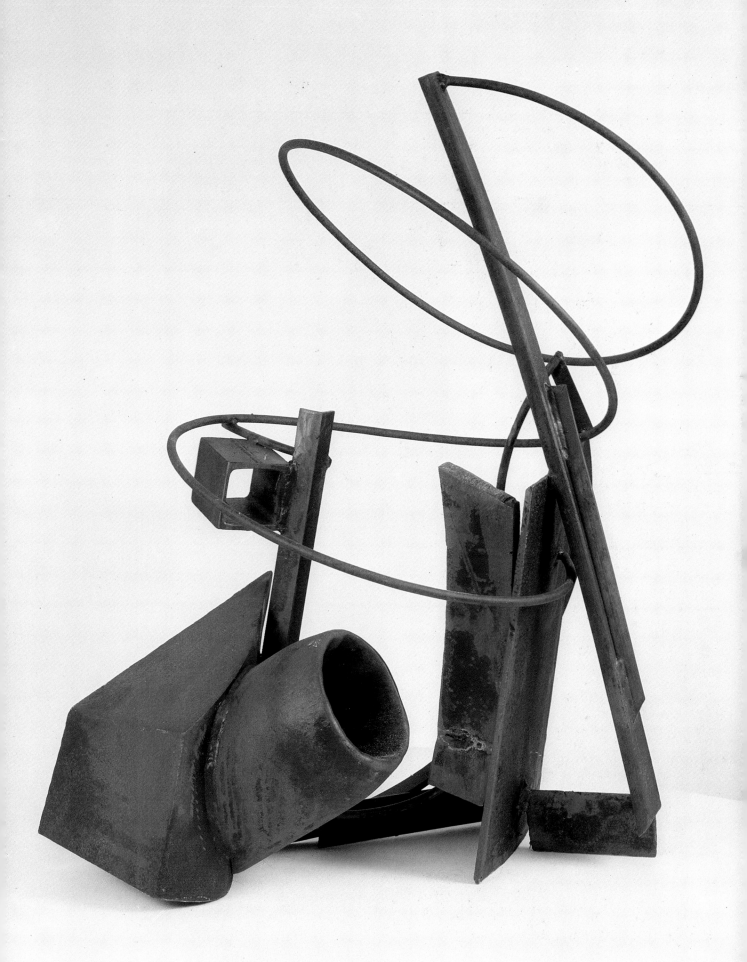

154 *Ocean*. 1982/83.
Steel rusted,
100′′ × 142′′ × 79′′ / 254 × 360.5 × 200.5 cm.

155 *Sheila's Song*. 1982.
Steel rusted and varnished,
82½′′ × 115′′ × 50′′ / 209.5 × 292 × 127 cm.

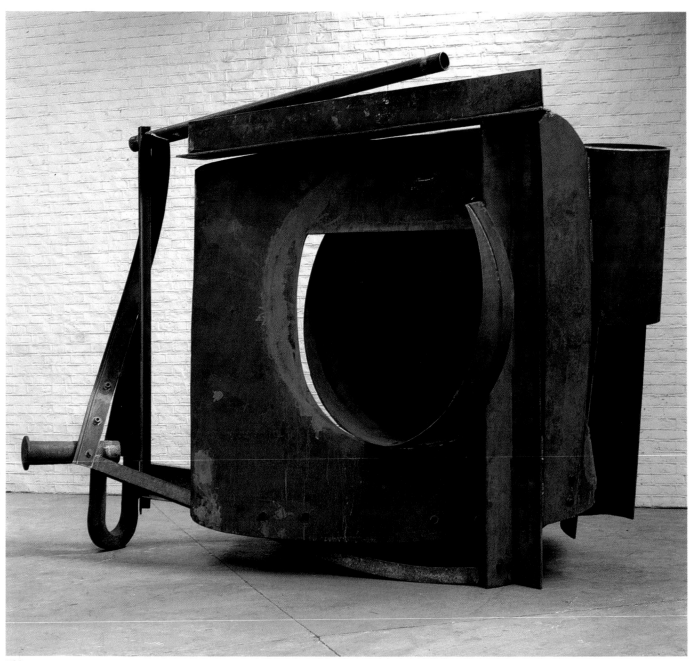

154

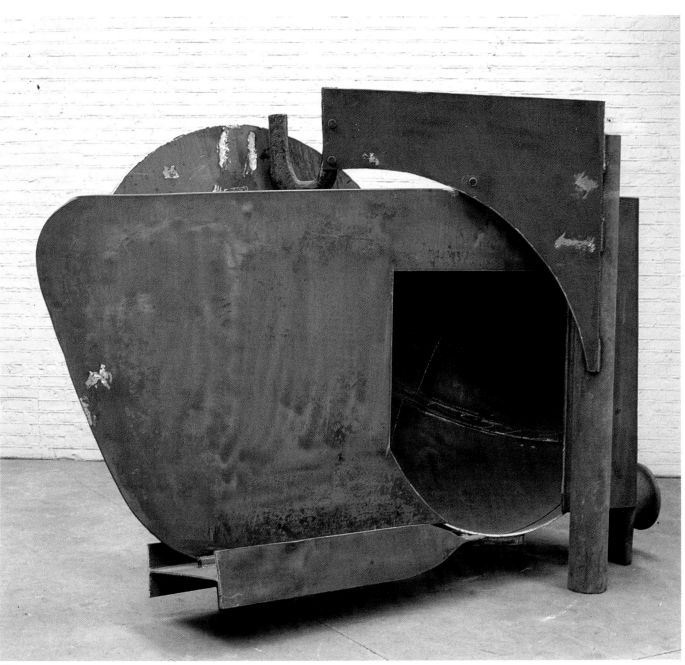

155

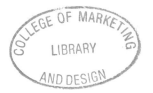

156 *Double Variation*. 1983/84.
Steel,
88'' × 120'' × 74'' / 223.5 × 305 × 188 cm.

157 *Odalisque*. 1983/84.
Steel,
77'' × 97'' × 64'' / 198 × 246 × 162.5 cm.

156

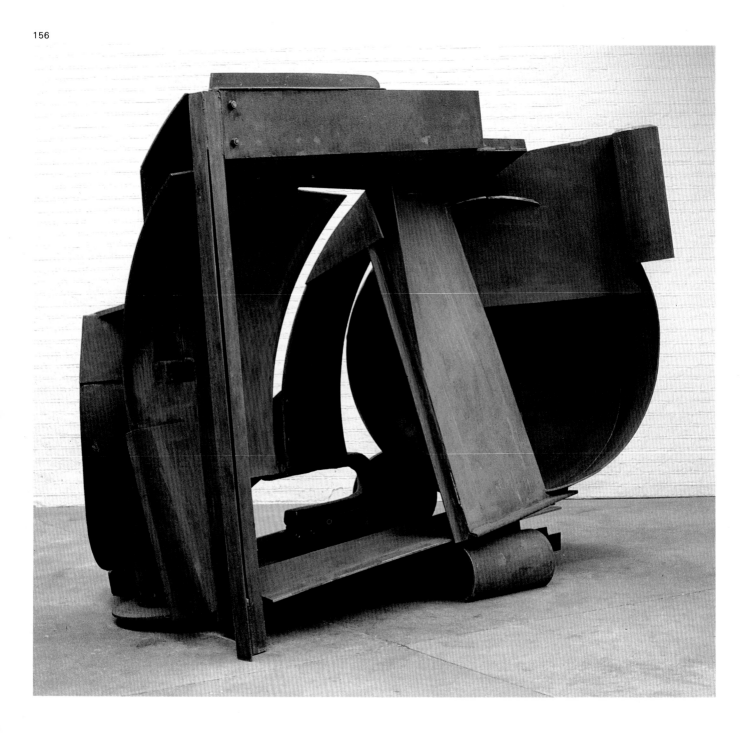

158 *The Soldier's Tale*. 1983.
Steel patinated and painted,
72'' × 82'' × 53'' / 183 × 208 × 134.5 cm.

159 *Dream Garden*. 1984.
Steel,
106½'' × 111'' × 75'' / 271 × 282 × 191 cm.

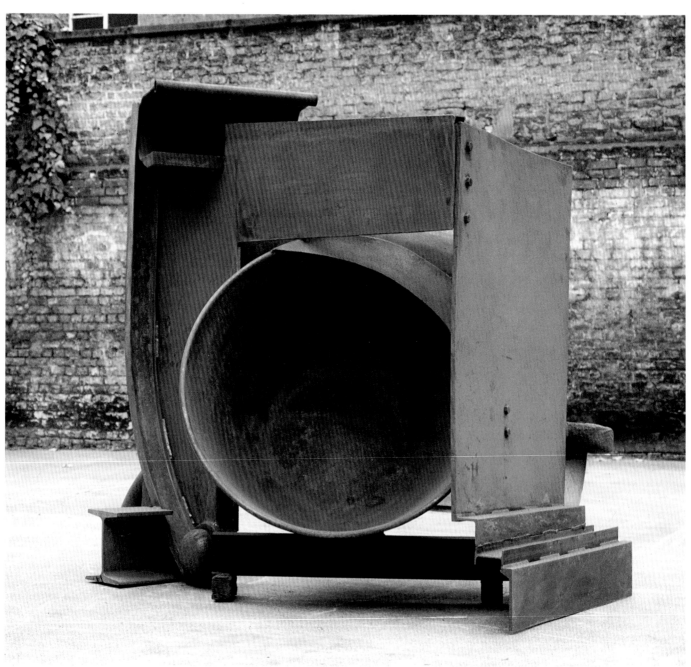

158

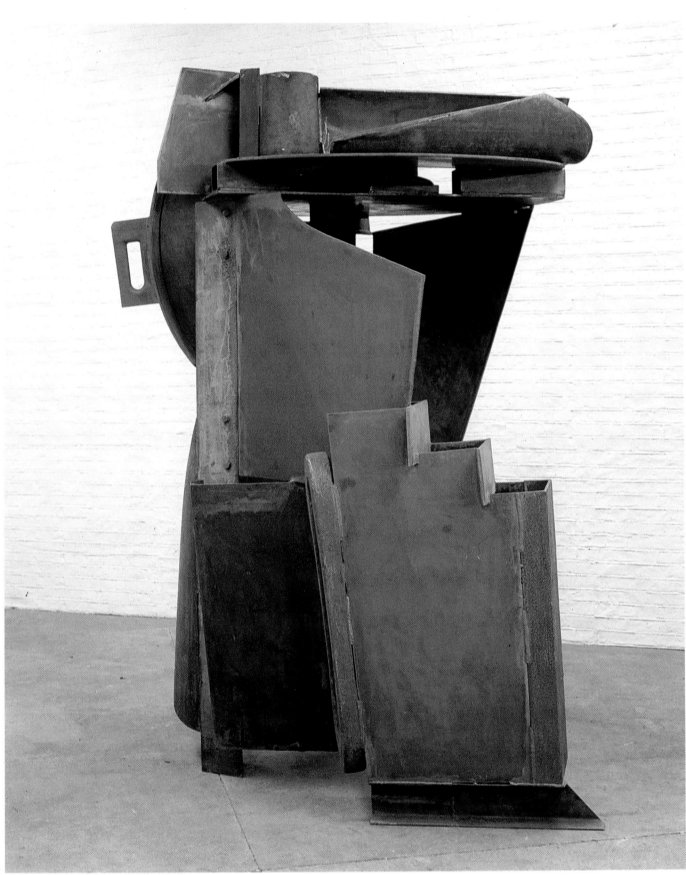

160-161 *"Small Tower"*. 1983/84.
Softwood painted (greys, cream, black, red),
80" × 51" × 53" / 203 × 129.5 × 134.5 cm.

162 Model for *Child's Tower Room:* Finished full-size tower as
follows:
Child's Tower Room. 1983/84.
Wood, Japanese Oak varnished,
150" × 108" × 108" / 381 × 274 × 274 cm.

160

161

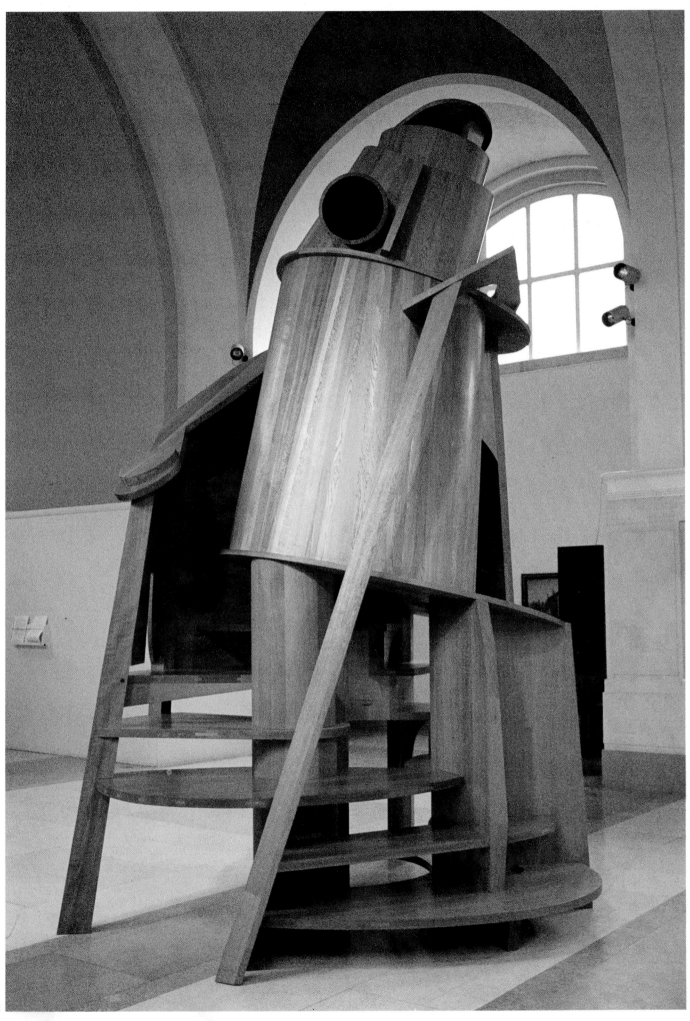

163 *Belt*. 1985.
Steel painted silver and brown,
94″ × 61″ × 73″ / 239 × 155 × 185.5 cm.

164 *Black Russian*. 1984/85.
Steel painted red and dark green,
92″ × 64″ × 69″ / 234 × 163 × 175 cm.

165 *Oracle*. 1983/85.
Steel painted and rubbed red and greys,
91½″ × 82″ × 79″ / 232 × 298.5 × 201 cm.

166 *Eastern*. 1983/85.
Steel painted cream and yellow ochre,
96″ × 84″ × 69″ / 244 × 213.5 × 175.5 cm.

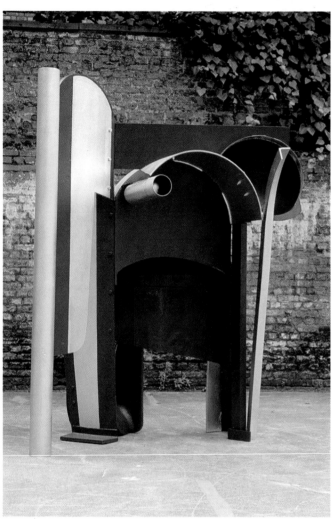

163

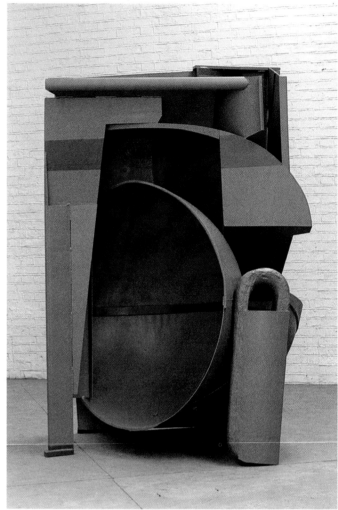

164

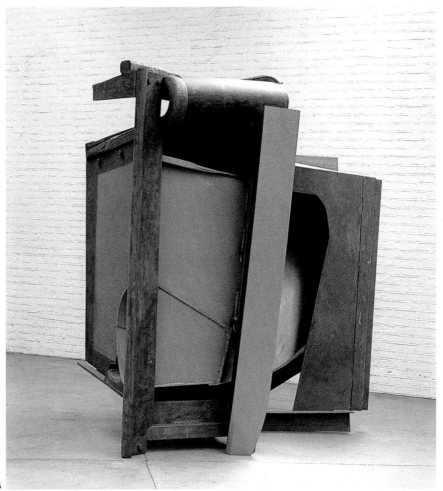

165

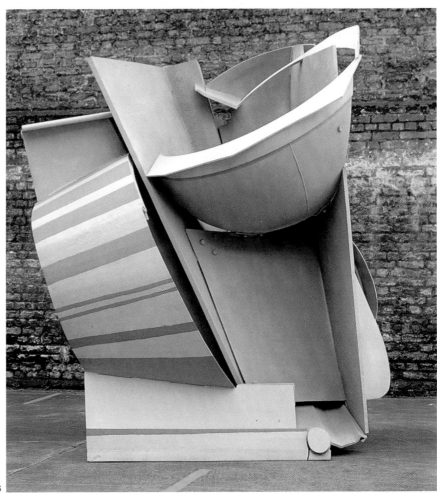

166

List of Illustrations

Dimensions are given in the order height, length, width

1 *Midday*. 1960.
Steel painted yellow,
94½'' × 38'' × 144'' / 240 × 96.5 × 366 cm.
Museum of Modern Art, New York

2 *Twenty-Four Hours*. 1960.
Steel painted dark brown and black,
54½'' × 88'' × 35'' / 138.5 × 223.5 × 89 cm.
Tate Gallery, London

3 *The Horse*. 1961.
Steel painted dark brown,
80'' × 38'' × 168'' / 203.5 × 96.5 × 427 cm.

4 *Sculpture Seven*. 1961.
Steel painted green, blue and brown,
70'' × 211½'' × 41½'' / 178 × 537 × 105.5 cm.

5 *Sculpture Three*. 1961.
Steel painted green,
117'' × 173'' × 55'' / 297 × 439.5 × 140 cm.

6 *Hop Scotch*. 1962.
Aluminium,
98½'' × 84'' × 187'' / 250 × 213.5 × 475 cm.

7 *Sculpture Three*. 1962.
Steel painted red,
108'' × 181'' × 67'' / 274.5 × 460 × 170.5 cm.
Walker Art Center, Minneapolis

8 *Early One Morning*. 1962.
Steel and aluminium, painted red,
114'' × 244'' × 131'' / 290 × 620 × 333 cm.
Tate Gallery, London

9 *Lock*. 1962.
Steel painted blue,
34½'' × 211'' × 120'' / 88 × 536 × 305 cm.

10 *Sculpture Two*. 1962.
Steel painted green,
82'' × 142'' × 102'' / 208.5 × 361 × 259 cm.

11 *Month of May*. 1963.
Steel and aluminium, painted magenta,
orange and green,
110'' × 120'' × 141'' / 279.5 × 305 × 358.5 cm.

12 *Bennington*. 1964.
Steel painted primer red,
40'' × 166'' × 133½'' / 102 × 422 × 339 cm.

13 *Pulse*. 1964.
Steel painted pink and green,
21½'' × 56'' × 111'' / 54.5 × 142.5 × 282 cm.

14 *Flats*. 1964.
Steel painted red and blue,
37½'' × 91'' × 120'' / 95.5 × 231.5 × 305 cm.

15 *Titan*. 1964.
Steel painted blue,
41½'' × 144'' × 114'' / 105.5 × 366 × 290 cm.

16 *Sleepwalk*. 1965.
Steel painted orange,
110'' × 100'' × 288'' / 279.5 × 254 × 731.5 cm.

17 *Strip*. 1965.
Steel and aluminium, painted red,
7'' × 3'' × 78¾'' / 18 × 7.5 × 200 cm.

18 *Sight*. 1965/69.
Steel painted blue,
112½'' × 66'' × 3'' / 286 × 168 × 7.5 cm.

19 *Wide*. 1964.
Steel and aluminium, painted burgundy,
58¾'' × 60'' × 160'' / 149.5 × 152.5 × 406.5 cm.

20 *Green Sleeper*. 1965.
Steel painted green,
12'' × 58'' × 43'' / 30.5 × 147.5 × 109 cm.

21 *Smoulder*. 1965.
Steel painted purple,
42'' × 183'' × 33'' / 106.5 × 465 × 84 cm.

22 *Shaftsbury*. 1965.
Steel painted purple,
27'' × 127'' × 108'' / 68.5 × 323 × 274.5 cm.

23 *Span*. 1966.
Steel painted burgundy,
77½'' × 184'' × 132'' / 197 × 468 × 335.5 cm.

24 *Deep Body Blue*. 1967.
Steel painted stark blue,
58½'' × 101'' × 124'' / 149 × 256.5 × 315 cm.

25 *Carriage*. 1966.
Steel painted blue,
77'' × 80'' × 156'' / 195.5 × 203.5 × 396.5 cm.

26 *The Window*. 1966/67.
Steel painted green and olive green,
84¾'' × 126¼'' × 153½'' / 215 × 320.5 × 390 cm.

27 *Source*. 1967.
Steel and aluminium, painted green,
73'' × 120'' × 141'' / 185.5 × 305 × 358 cm.
Museum of Modern Art, New York

28-29 *Prairie*. 1967.
Steel painted matt yellow,
38'' × 229'' × 126'' / 96.5 × 582 × 320 cm.

30 *Table Piece XVIII*. 1967.
Steel polished and lacquered,
10'' × 21'' × 20'' / 25.4 × 53.3 × 50.8 cm.

31 *Table Piece XIV*. 1966.
Steel polished,
10'' × 24'' × 19½'' / 25.4 × 61 × 49.5 cm.

32 *Table Piece XXXVII*. 1967.
Steel painted grey,
20½'' × 21'' × 14¾'' / 52.1 × 53.3 × 37.5 cm.

33 *Table Piece XXII*. 1967.
Steel sprayed jewelescent green,
10'' × 31½'' × 27'' / 25.4 × 80 × 68.6 cm.

34 *Table Piece LXIV (The Clock)*. 1968.
Steel painted zinc chromate primer,
30'' × 51'' × 32'' / 76.2 × 129.5 × 81.3 cm.

35 *Table Piece XLII*. 1967.
Polished steel sprayed green,
23½'' × 15½'' × 29'' / 59.7 × 39.4 × 73.7 cm.

36 *Trefoil*. 1968.
Steel painted matt yellow,
83'' × 100'' × 65'' / 211 × 254 × 165 cm.

37 *Table Piece LIX*. 1968.
Steel sprayed silver grey,
11½'' × 17'' × 19'' / 29.2 × 43.2 × 48.3 cm.

38 *Table Piece LXXXVIII (Deluge)*. 1969.
Steel painted zinc chromate primer,
40'' × 63'' × 38'' / 101.6 × 160 × 96.5 cm.

39 *Table Piece XLIX*. 1968.
Steel painted green,
20½'' × 32'' × 25'' / 52.1 × 81.3 × 63.5 cm.

40 *Table Piece LVIII*. 1968.
Steel sprayed cherry,
20¼'' × 32'' × 31'' / 50.6 × 80 × 77.5 cm.
Kunsthalle, Hamburg

41 *After Summer*. 1968.
Steel painted grey,
62'' × 236'' × 288'' / 157.5 × 599.5 × 731.5 cm.

42 *Argentine*. 1968.
Steel painted purple,
59'' × 140'' × 124'' / 150 × 355.5 × 315 cm.

43 *Orangerie*. 1969.
Steel painted red,
88½'' × 64'' × 91'' / 225 × 162.5 × 231 cm.

44 *Deep North*. 1969/70.
Steel and aluminium, painted green,
96'' × 228'' × 114'' / 244 × 579 × 289.5 cm.

45 *Garland*. 1970.
Steel painted green and red,
55'' × 169'' × 148'' / 140 × 429.5 × 376 cm.

46 *Table Piece XCVII*. 1970.
Steel painted tan,
25'' × 53'' × 44'' / 63.5 × 134.6 × 111.8 cm.

47 *Table Piece XCI*. 1969/70.
Steel painted brown,
20'' × 62'' × 41'' / 50.8 × 157.5 × 104.1 cm.

48 *Tempus*. 1970.
Steel painted green,
45'' × 46½'' × 47'' / 114.5 × 118 × 119.5 cm.

49 *Wending Back*. 1969.
Steel painted grey,
43'' × 126'' × 102'' / 109 × 320 × 259 cm.
Cleveland Museum of Art, Cleveland, Ohio

50 *Sun Feast*. 1969/70.
Steel painted yellow,
71½'' × 164'' × 86'' / 181.5 × 416.5 × 218.5 cm.

51 *The Bull*. 1970.
Steel rusted,
32'' × 119'' × 57'' / 81.5 × 302.5 × 145 cm.

52 *Ordnance*. 1971.
Steel rusted and varnished,
51'' × 76'' × 143'' / 129.5 × 193 × 363 cm.

53 *Picket*. 1970.
Steel rusted,
39'' × 65½'' × 34'' / 99 × 166.5 × 86.5 cm.

54 *Side Step*. 1971.
Steel painted brown,
51'' × 115'' × 58'' / 129.5 × 292 × 147.5 cm.

55 *Canal*. 1971.
Steel rusted,
41'' × 72½'' × 65'' / 104 × 184 × 165 cm.

56 *Cool Deck*. 1970/71.
Stainless steel,
22'' × 64'' × 124'' / 56 × 162.5 × 315 cm.

57 *Box Piece F*. 1972.
Stainless steel,
20½'' × 73'' × 23'' / 52.1 × 185.4 × 58.4 cm.
Edmonton Art Gallery, Edmonton, Alberta

58 *Up Front*. 1971.
Steel painted red,
69'' × 110'' × 46½'' / 175.5 × 279.5 × 118 cm.
Detroit Institute of Arts, Detroit

59 *Crown*. 1970/71.
Steel painted red,
42½'' × 82'' × 32'' / 108 × 208.5 × 81.5 cm.

60 *Cherry Fair*. 1971.
Steel painted brown,
36'' × 87'' × 74'' / 91.5 × 221 × 188 cm.

61 *Straight On*. 1972.
Steel rusted with red paint rubbed in,
79'' × 68'' × 52'' / 201 × 173 × 132 cm.

62 *Straight Up*. 1972.
Steel rusted,
56'' × 43'' × 68'' / 142 × 109 × 173 cm.

63 *Straight Cut*. 1972.
Steel rusted and painted silver,
52'' × 62'' × 51'' / 132 × 157.5 × 129.5 cm.

64 *Straight Measure*. 1972.
Steel rusted and painted,
46½'' × 75'' × 59'' / 118 × 190.5 × 150 cm.

65 *Veduggio Sun*. 1972/73.
Steel rusted and varnished,
99'' × 120'' × 54'' / 251.5 × 305 × 137 cm.
Museum of Fine Arts, Dallas

66 *Veduggio Plain*. 1972/73.
Steel rusted and varnished,
63'' × 90'' × 78'' / 160 × 228.5 × 198 cm.

67 *Durham Steel Flat*. 1973/74.
Steel rusted and varnished,
111½'' × 98½'' × 70½'' / 283 × 250 × 179 cm.

68 *Table Piece CLXXXIII*. 1974.
Steel varnished,
20'' × 78'' × 22'' / 50.8 × 198.1 × 55.9 cm.

69 *Table Piece CLXXXVI*. 1974.
Steel varnished,
18'' × 64'' × 25'' / 45.7 × 162.6 × 63.5 cm.

70 *Durham Purse*. 1973/74.
Steel rusted and varnished,
48'' × 147'' × 30'' / 122 × 373.5 × 76 cm.
Boston Museum of Fine Arts, Boston

71 *Curtain Road*. 1974.
Steel rusted and varnished,
78'' × 188'' × 109'' / 198 × 475.5 × 277 cm.

72 *Surprise Flats*. 1974.
Steel rusted and varnished,
122'' × 136'' × 113'' / 310 × 345,5 × 287 cm.

73 *Hot Dog Flats*. 1974.
Steel rusted and varnished,
78'' × 212'' × 81'' / 198 × 538,5 × 206 cm.

74 *Riviera*. 1971/74.
Steel rusted and varnished,
127'' × 325'' × 120'' / 322.5 × 825.5 × 305 cm.
Virginia Wright Fund, Seattle

75 *Sailing Tonight*. 1971/74.
Steel rusted and varnished,
63'' × 161'' × 26'' / 160 × 409 × 66 cm.

76 *Scheherazade*. 1974.
Steel rusted and varnished,
102½'' × 165'' × 108''/260.5 × 419 × 274.5 cm.

77 *Flank*. 1976.
Steel rusted and varnished,
74'' × 68'' × 67'' / 188 × 173 × 170 cm.

78 *Caramel*. 1975.
Steel,
58'' × 60'' × 35'' / 147.5 × 152.5 × 89 cm.

79 *Nectarine*. 1976.
Steel rusted and varnished,
79'' × 107'' × 51'' / 201 × 272 × 129.5 cm.

80 *Footprint*. 1975.
Steel,
85'' × 119'' × 66'' / 216 × 302.5 × 167.5 cm.

81 *Table Piece CXVI*. 1973.
Steel rusted and varnished,
32'' × 36'' × 25½'' / 81.3 × 91.4 × 64.8 cm.

82 *Table Piece CCXIII (Granada)*. 1974.
Steel rusted and varnished,
34'' × 55'' × 16'' / 86.4 × 139.7 × 40.6 cm.

83 *Table Piece CC*. 1974.
Steel varnished,
25½'' × 76½'' × 44'' / 64.8 × 194.3 × 111.8 cm.

84 *Table Piece CCIII*. 1974.
Steel varnished,
23'' × 90'' × 17'' / 58.4 × 228.6 × 43.2 cm.

85 *Piece CCXXVIII*. 1975.
Steel rusted and varnished,
17'' × 53'' × 15'' / 43.2 × 134.6 × 38.1 cm.

86 *Dumbfound*. 1976.
Bright steel painted green,
21'' × 50'' × 15'' / 53.5 × 127 × 38 cm.

87 *Slide Left*. 1976.
Steel rusted and varnished,
16½'' × 77'' × 23'' / 42 × 195.5 × 58.5 cm.
Edmonton Art Gallery, Edmonton, Alberta

88 *Table Piece CCXLVII*. 1975.
Steel rusted and varnished,
27'' × 56'' × 20'' / 68.6 × 142.2 × 50.8 cm.

89 *Table Piece CCC*. 1975/76.
Steel and sheet steel rusted and varnished,
38½'' × 52'' × 13'' / 97.8 × 132.1 × 33 cm.

90 *Table Piece CCLXII*. 1975.
Steel and sheet steel rusted and varnished,
20'' × 40'' × 26'' / 50.8 × 101.6 × 66 cm.

91 *Table Piece CCLXXX*. 1975/76.
Steel rusted and varnished,
31'' × 59½'' × 23½'' / 78.7 × 151.1 × 59.7 cm.

92 *Floor Piece C 38*. 1975/76.
Steel rusted and varnished,
28'' × 58'' × 36'' / 71.1 × 147.3 × 91.5 cm.

93 *Midnight Gap*. 1976/78.
Steel rusted, varnished and painted green,
71'' × 142'' × 110'' / 180.5 × 361 × 279 cm.
Vancouver Art Gallery, Vancouver

94 *Fathom*. 1976.
Steel rusted and varnished,
81'' × 305'' × 66'' / 206 × 775 × 167.5 cm.

95 *Emma This*. 1977.
Steel rusted, painted red and blacked,
59'' × 102'' × 73'' / 150 × 259 × 185.5 cm.

96 *Emma That*. 1977.
Steel rusted, painted red and blacked,
52½'' × 56'' × 107'' / 133.5 × 142 × 272 cm.

97 *Emma Dipper*. 1977.
Steel rusted and painted grey,
84'' × 67'' × 126'' / 213.5 × 170 × 320 cm.

98 *Emma Dance*. 1977/78.
Steel rusted, painted and blacked,
94½'' × 98'' × 111'' / 240 × 249 × 282 cm.

99-102 *National Gallery Ledge Piece*. 1977.
Steel rusted and painted grey,
174'' × 235'' × 107'' / 442 × 597 × 272 cm.
National Gallery, Washington, D.C.

103 *Floor Piece C 92 (Medicine Hat)*. 1975/77.
Steel and sheet steel and galvanised
wire, painted and sprayed grey,
30'' × 60'' × 39'' / 76.2 × 152.4 × 99.1 cm.

104 *Table Piece CCCLIV*. 1976/77.
Steel rusted and varnished,
23¼'' × 57'' × 13½'' / 59.1 × 144.8 × 34.3 cm.
Kunsthalle, Mannheim

105 *Table Piece CCCXIII*. 1976/77.
Steel and sheet steel rusted and varnished,
30'' × 40'' × 14'' / 76.2 × 101.6 × 35.6 cm.

106 *Table Piece CCCX*. 1976/77.
Steel rusted and varnished,
20'' × 63'' × 39'' / 50.8 × 160 × 99.1 cm.
British Council

107 *Table Piece CCCXXXII (Rosette)*.
1976/77.
Steel and cast iron, rusted and varnished,
13'' × 28'' × 22'' / 33 × 71.1 × 55.9 cm.

108 *Table Piece CCCC (Four C'S)*. 1977/78.
Steel rusted and varnished,
42⅛'' × 59'' × 22¾'' / 107 × 150 × 58 cm.

109 *Table Piece CCCLXXXVIII*. 1977.
Steel rusted and varnished,
40½'' × 44'' × 21'' / 102.9 × 111.8 × 53.3 cm.

110 *Paper Sculpture No. 105
(Punch and Judy)*. 1981.
Pencil, chalk, acrylic, 4 push pins, Tycore,
handmade paper in wood box,
34½'' × 21'' × 8½'' / 87.6 × 53.3 × 21.6 cm.

111 *Paper Sculpture No. 24 (As You Are)*.
1981.
Pencil, acrylic, handmade paper on Tycore,
38¼'' × 24'' × 4'' / 97.2 × 61 × 10.2 cm.

112 *Paper Sculpture No. 97*. 1981.
Pencil, acrylic, spray paint, handmade paper
on Tycore,
25½'' × 25½'' × 6½'' / 64.8 × 64.8 × 16.5 cm.

113 *Paper Sculpture No. 4 (Big White)*. 1981.
Pencil, chalk, acrylic, handmade paper
on Tycore,
32'' × 38⅜'' × 7½'' / 81.3 × 97.5 × 19 cm.

114 *Great Jones Landscape*. 1983.
Stoneware coloured and painted,
8'' × 38'' × 19'' / 20.5 × 96.5 × 48 cm.

115 *Great Jones Triangle*. 1983.
Stoneware coloured and painted,
12½'' × 26'' × 20¾'' / 31.5 × 66 × 52.5 cm.

116 *Can Co Galore*. 1977.
Stoneware,
8'' × 11'' × 25'' / 20.3 × 27.9 × 62.5 cm.

117 *Can Co Cut*. 1975/76.
Stoneware,
12'' × 13'' × 36'' / 30.5 × 33 × 91.4 cm.

118 *Mint Chiffon*. 1978/79.
Bronze cast and welded,
54'' × 33'' × 24'' / 137.2 × 83.8 × 61 cm.

119 *Buddha Peach*. 1976/78.
Bronze cast and welded,
36¾'' × 24'' × 20'' / 93.5 × 61 × 50.8 cm.

120 *Table Bronze the Mosque*. 1979/80.
Bronze cast and and welded, and brass,
33½'' × 37'' × 29½'' / 85.1 × 94 × 75 cm.

121 *Stainless Piece A-F*. 1979.
Stainless steel,
16½'' × 43'' × 30'' / 41.9 × 109.2 × 76.2 cm.

122 *Writing Piece ''Bake''*. 1979.
Steel rusted and blacked,
13'' × 28'' × 11'' / 33 × 71.1 × 27.9 cm.

123 *Writing Piece ''Blank''*. 1979.
Steel,
12½'' × 33'' × 11½'' / 31.8 × 83.8 × 29.2 cm.

124 *Writing Piece ''Were''*. 1979.
Steel,
27'' × 40'' × 12'' / 68.6 × 101.6 × 30.5 cm.

125 *Writing Piece ''Good''*. 1979.
Steel, cast iron and wood, painted,
24½'' × 14'' × 19'' / 62.2 × 35.6 × 48.3 cm.

126 *Writing Piece ''Whence''*. 1978.
Steel rusted, painted and blacked,
12½'' × 34'' × 6½'' / 31.7 × 86.4 × 16.5 cm.

127 *Table Piece Z-18 (Balcarres)*. 1980.
Steel rusted and varnished,
13'' × 57'' × 13'' / 33 × 144.8 × 33 cm.

128 *Half Dollar*. 1980.
Bronze cast and welded, and brass,
27½'' × 25½'' × 22'' / 70 × 64.8 × 55.9 cm.

129 *Late Quarter*. 1979.
Bronze cast and welded, and brass,
13'' × 16'' × 20'' / 33 × 40.6 × 50.8 cm.
Edmonton Art Gallery, Edmonton

130 *Half Moon*. 1980.
Bronze cast and welded, and brass,
28½'' × 31'' × 20½'' / 72.4 × 78.7 × 52.1 cm.
Arts Council of Great Britain

131 *Water Street Table Bronze Starter*. 1980.
Bronze cast and welded,
22'' × 24'' × 17'' / 55.9 × 61 × 43.2 cm.

132 *Water Street Straddle*. 1980.
Bronze cast and welded, copper and
brass sheet,
36'' × 52'' × 30'' / 91.4 × 132.1 × 76.2 cm.

133 *Water Street Return*. 1980.
Bronze cast and welded, and copper,
48'' × 30'' × 20'' / 121.9 × 76.2 × 50.8 cm.

134 *Bronze Screen ''Gala''*. 1981.
Bronze cast and welded,
70'' × 49'' × 20½'' / 178 × 124.5 × 52 cm.

135 *Bronze Screen ''Return''*. 1981.
Bronze cast and welded,
66'' × 37'' × 18'' / 167.5 × 94 × 45.5 cm.